Wild Horses of the Dunes

Wild Horses of the Dunes

Text and Photography by Rich Pomerantz

COURAGE
B O O K S

An Imprint of Running Press
Philadelphia • London

9 8 7 6 5 4 3 2 1
Digit on the right indicates the number of this printing

Library of Congress Cataloging-in-Publication Number 2003110222

ISBN 0-7624-1775-7

Cover by Alicia Freile
Interior design by e Bond

This book may be ordered by mail from the publisher.
But try your bookstore first!

Published by Courage Books, an imprint of
Running Press Book Publishers
125 South Twenty-second Street
Philadelphia, Pennsylvania 19103-4399

Visit us on the web!
www.runningpress.com

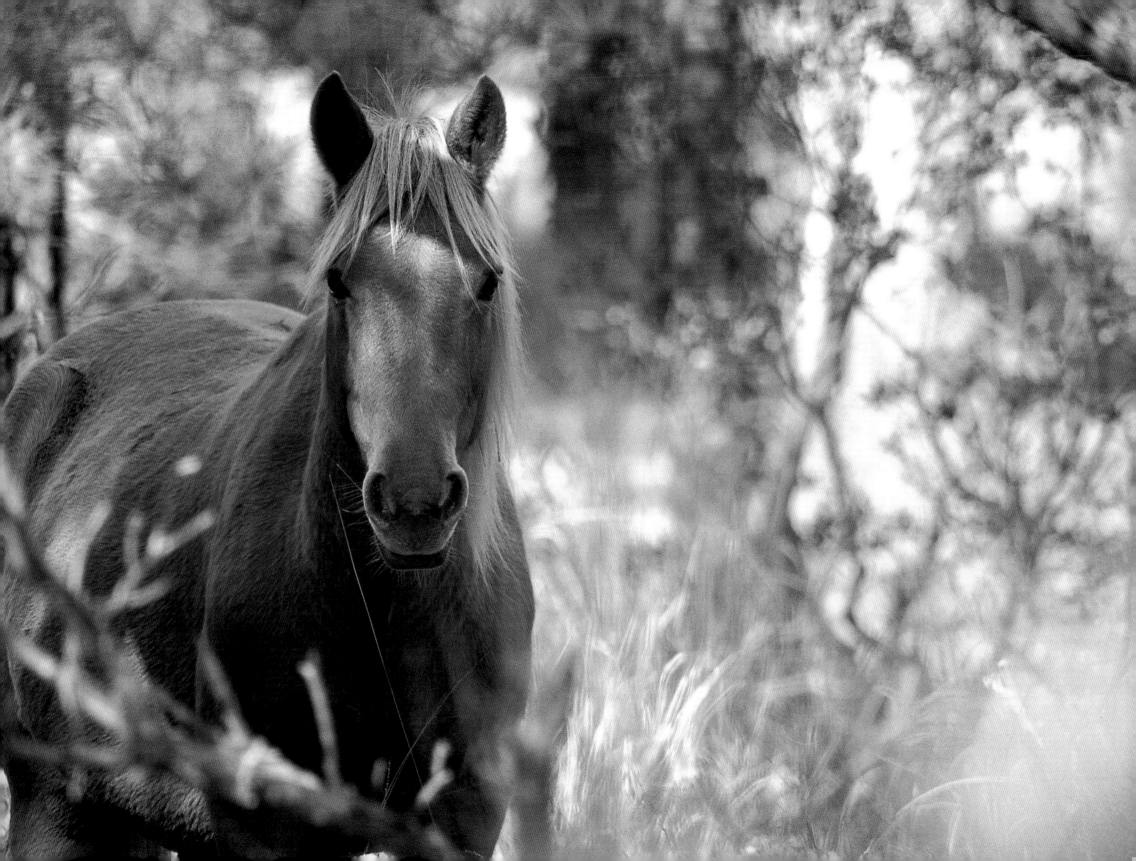

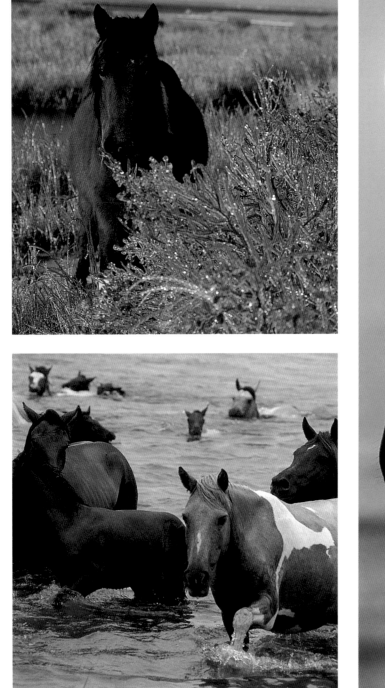
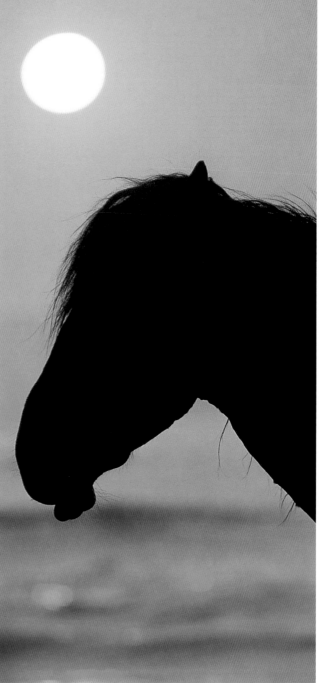
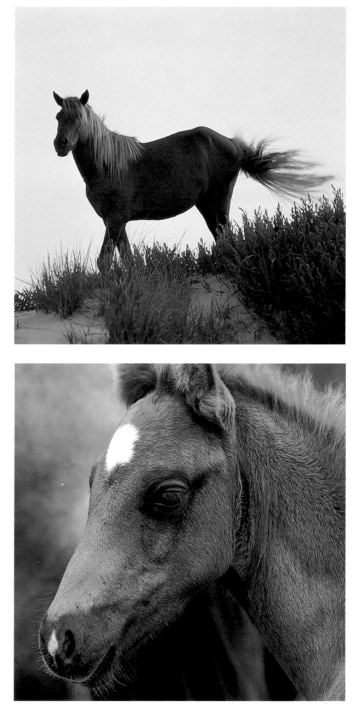

CONTENTS

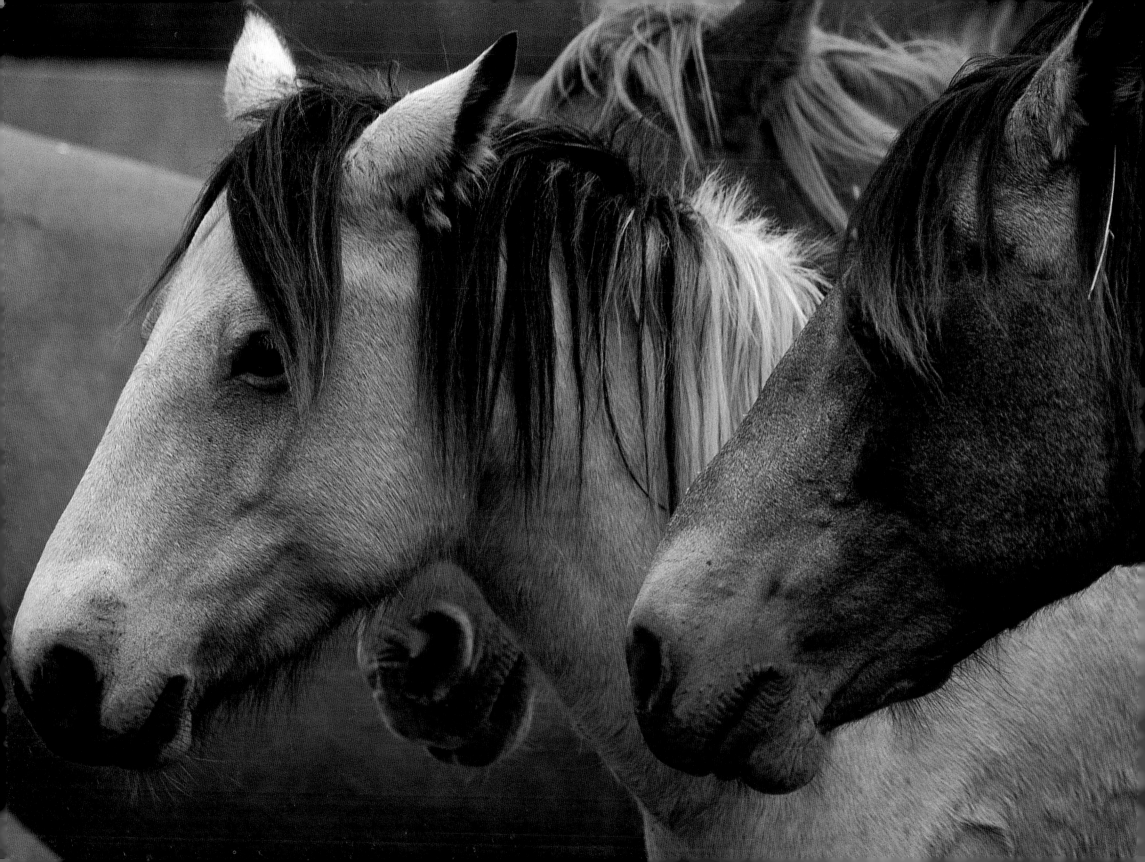

ACKNOWLEDGMENTS

There are many people whose help was indispensable to the creation of this book, whether they know it or not.

There are the obvious ones: those wonderful people at Running Press who first saw the potential in my proposal, and Connie and David Cherrix who befriended me and let me into the warm and hard-working world of the Chincoteague Volunteer Firemen and the pony pennings. David's stories of growing up on Chincoteague and his over 50 years of pony pennings taught me the value of the symbiotic relationship that exists between the Chincoteaguers and the horses. Ultimately, this became the thesis for the book. He is a tough guy, a true redneck with a sweet and gentle soul, and who has a classic island accent that I could never in a million years imitate. And, like all of the firemen, David has a deep and unshakable love for the horses.

Other Chincoteaguers and cowboys who deserve thanks for their help and their stories include June and Jack Mohr, Walter Marks, Bobby Lapin, Lloyd, Naomi and Stephanie Belton, Roe Terry, Burt Cherrix, Denise Bowden, Kathryn and Wayne Tolbert, Suzanne Taylor, Jackie Russell, Richard Thomas and so many others.

Many photographers gave me support and encouragement. Judy Hermann first planted the idea in my head to do this book, Howard Schatz and Beverly Ornstein always give me excellent advice and encouragement, Norm Cummings, Lynn Damon, Seth Resnick, Gary Gladstone, Barry O'Rourke, Kirsten Scully, Georgia Sheron, Michele Stapleton, Tom Wilson, Bob Zemba, and everyone on the photopro list at www.photonews.com, an amazing online community of photographers. Jane and Eli Arochas, my personal innkeepers for many of my trips to Assateague. Leonard Phillips at Gladstone Media was the first to see the potential and publish my Assateague wild horse images.

The Maizels, Sydney Eddison, the Chebots, Steve Bliss and Roberta Reed all helped more than they know. None of this would have happened without the kick in the pants I got from Elise Gold or the brilliant design help I received from Nancy Hamlen.

My parents deserve thanks for fostering in me the drive to see a project like this through to the end, regardless of the difficulties.

Finally, nothing good in my life happens without the support I receive from my wife Celia, and daughter, Sara. They give me room to pursue my art and career without complaint, enduring weeks and months of my absence, both physically and psychically, while I attend to photography, the fourth member of our family. I can't thank them enough for their love.

LEFT: Profiles in color.
PAGE 3: Wild ponies running on Assateague.
PAGE 5: A mare in the loblolly pine forest in autumn, watching for signs of danger.
PAGE 6 TOP LEFT: A wild horse in an ice covered salt marsh.
PAGE 6 BOTTOM LEFT: Wild horses emerging from swimming in Chincoteague Channel.
PAGE 6 CENTER: A sunrise silhouette.
PAGE 6 TOP RIGHT: A stallion on the dunes.
PAGE 6 BOTTOM RIGHT: A large foal at pony penning.

PREFACE

Encountering a blond stallion at sunrise coming over a beach dune, I felt very much like I imagined a human would feel meeting an alien from another galaxy. We both stood and examined each other warily for a while. Determining that there was no danger (the horse determined this rather more quickly than I), we settled into creating a new language, so that we could communicate as neither of us had ever done before. At least, that is what I did, speaking softly to him, moving slowly around him so that I could create the images I was envisioning in the magic of the early morning light. He, on the other hand, just relaxed, reclining there on the dune and watching me, occasionally shaking a green-headed fly off his nose.

Abiding by common sense, not to mention the rules of the National Seashore, I never ventured too close, always observing him watching me carefully yet nonchalantly, in that amazingly sensitive equine way that only a horse can muster. As my shutter whirred, I kept speaking to him, trying to soothe him. For all I know, he thought I was a total fool. Maybe I was. It was my first encounter with one of these magnificent feral animals. The first of a great many to come, I hoped. I was most definitely a fool, as complete as they come. Anyone who has been smitten by horses knows what I am talking about.

I photographed that blond stallion for as long as I could. Eventually, the summer sun became too strong, at which point my subject decided to move on, strolling north up the beach to get some relief from the biting flies in the breeze coming in off the ocean. I knew then that I would return to this place as often as I could, to learn about these magnificent animals, and to create images of them that would convey, I hoped, their beauty *in this place*.

I am convinced that the relationship of the horses to Assateague, and that of the people of the region to the horses, is unique and very special. When I cross the bridge over Chincoteague Bay and set foot on Assateague, something clicks inside of me. My words alone cannot adequately describe what that something is. Fortunately, I have my camera to help explain my wonder. I have tried with my photographs to capture the particular beauty and nobility of all horses. However, I also hope readers of this book will look at these photographs and understand something of the world of the horses that roam this narrow piece of land on the edge of the Atlantic.

RIGHT: Blond wild stallion reclining on a beach dune at sunrise.

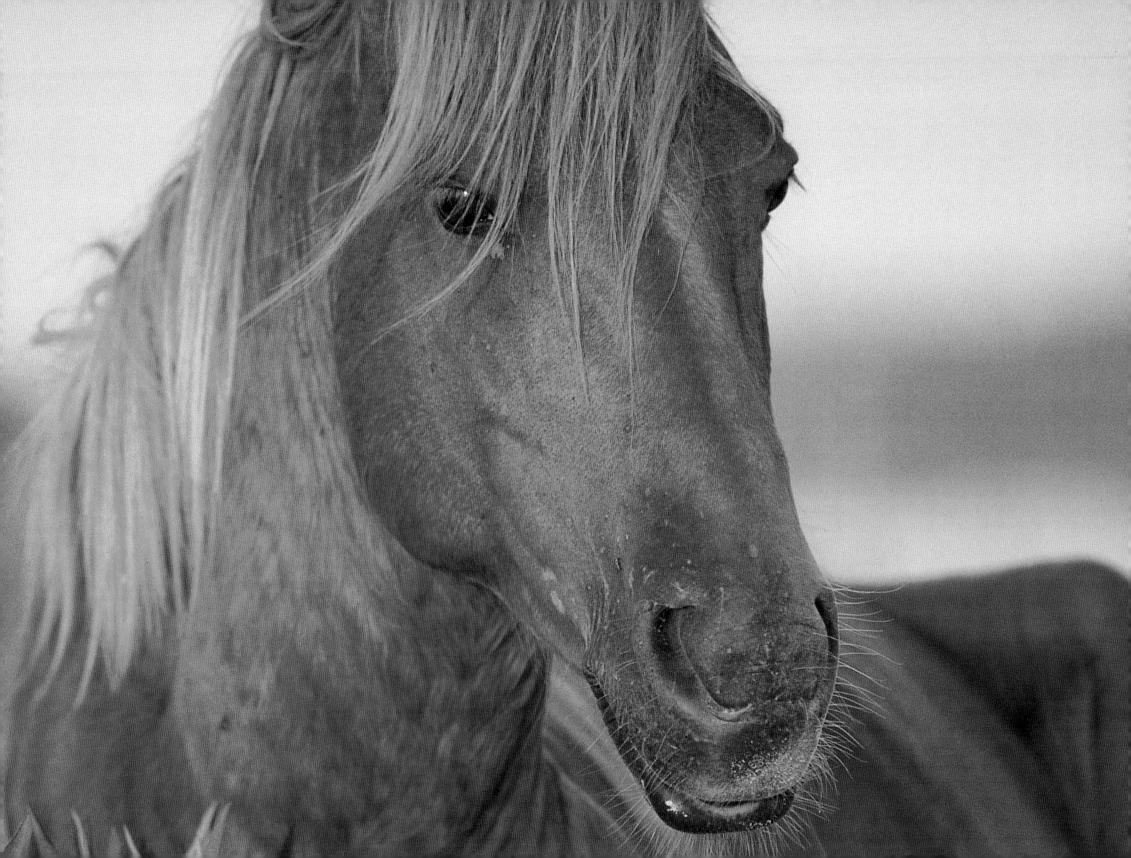

INTRODUCTION

The origin of the horses on Assateague is shrouded in mystery and obscured by debate. One romantic though unlikely theory has 17th-century pirates combing a narrow, sandy island off the coast of Maryland looking for a place to bury their ill-gotten treasure, leaving behind a herd of horses to use as emergency meat if they needed to return under exigent circumstances. No one disputes that pirates were active in the region; it is also well known that they found a convenient refuge in Chincoteague Inlet between the islands of Chincoteague and Assateague and along the many coves and marshes on Assateague Island. Historians know that the famous pirate Blackbeard was active in the region, as were others. A letter found in a trunk in Germany in 1948 signed by Charles Wilson, a pirate hanged by the English authorities in 1750, indicates a location on Assateague where he buried treasure valued at 200,000 pounds sterling. Unfortunately, the treasure was never found. So it seems almost plausible that these marauders may have left behind a few horses. A Hollywood screenwriter might like this version, but despite these credible reports historians do not give it much credence as being the origin of the horses.

A different theory contends that the horses swam ashore from one of the many shipwrecks for which the nearby Atlantic is known. The story most often mentioned claims that in 1820, a Spanish galleon called the San Lorenzo, filled with gold, silver and carrying blind Peruvian horses, foundered and sank near Assateague in one of the brutally wild storms that regularly pass through the region. The horses swam ashore to the same mysterious island—Assateague—and for years afterward were seen by visitors from the nearby mainland wandering the pine forest like shadows.

There certainly were many shipwrecks in the area through the years; barrier islands are notorious for sheltering hidden and shifting sand bars nearby on which it is easy for a large ship to run aground. During the 18th

century and into the 19th, the locals supplemented their income by salvaging what they could from the wrecks, although the practice was outlawed in 1799. Moreover, the San Lorenzo's documents have survived, and they verify that the vessel was carrying ninety-five horses. The captain survived the wreck and confirmed that the horses were aboard when the ship encountered its demise.

While the local tourist boards love these stories—which do have some kernels of historical accuracy buried in them—upon scrutiny, they don't hold up. The biggest problem is that horses were known to be wandering these islands long before these events. So how then did groups of wild horses come to inhabit a 23-mile-long barrier island? Somehow, horses found their way to this beautiful coastal island whose name means "a running stream between," in the local native language.

Documentation shows that there have been horses on Assateague for a long time, at least since the 17th century and probably earlier. Throughout the 19th century and into the 20th, local settlers conducted roundups of the animals, not just horses, but also sheep and cows living on Assateague. These "pennings" became regular events long ago. Sheep and cows continued to inhabit Assateague as late as the 1940s. One of the oldest cowboys still riding, George Foskey, tells of rounding up cattle on Assateague when he was a teenager. One year, he waited for a stubborn bull that wandered out into the surf too far to be roped. It refused to come back ashore for several hours. But like any good saltwater cowboy, Foskey waited for the bull to tire of the game and return to shore.

The earliest published account of the pony pennings dates from 1835, and refers to it as an "ancient" practice. There are also many accounts of sheep pennings taking place earlier than the pony pennings. But the question remains: how did the horses get there in the first place?

The most accepted view is not as entertaining as pirates or shipwrecks, but has the strong (though mundane) ring of truth. We have all heard the phrase: "follow the money." Therein lies the clue.

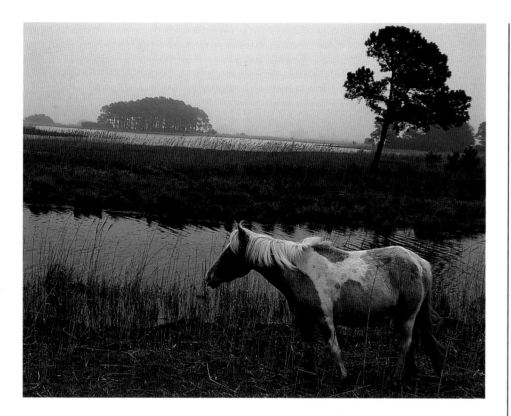

The Atlantic coast is lined by a string of barrier islands. Most are long and narrow with beautiful white sandy beaches facing the Atlantic Ocean and have sheltered marsh and pine forested coves mostly facing the mainland sides. These islands sit in a line running from Maryland and Virginia south past the Carolinas down to Georgia. Any good student of American history knows about the tax revolts against the English monarchy that presaged the American Revolution. In colonial times, taxes were levied on fences used to pen in livestock, and tax collectors were dispatched to enforce the rule. However, people who lived near the coast found that by transporting or swimming their herds of sheep, cattle or horses across narrow bays and channels to the nearby offshore islands, they could keep their assets from the prying eyes of the tax man. Not only had they figured out an effective tax avoidance strategy, but they could also safeguard their herds without the need for building fences to keep them in, or monitoring them to keep predators (nonexistent for the most part on the islands) out.

Although they are not as famous as those on Assateague, the existence of wild horses on many of these islands is no secret. Assateague may be the best known, but in recent years many other islands, including Ocracoke, Shackleford Banks, Carrot Island in North Carolina and Cumberland Island in Georgia, still supported groups of free-ranging feral horses descended from the original objects of the tax man's lust. Some are kept in pens for tourists, while other populations still roam free, although many are reported to be dwindling or hard to find.

The Assateague horses owe their origins to modern man's conventional impulse to preserve his capital and keep it out of the hands of the government. There may well have been pirates or shipwrecks that dumped their cargo nearby, including a few horses lucky enough to have swum ashore and add their genetic makeup to the equine soup already brewing on Assateague, but as far as the origin of the species, the conventional wisdom holds that it was primarily man's usual disdain for paying taxes that points to the truth.

The fundamental point to all of the versions of the origins of the Assateague horses is that in every one it was the actions of people which put the horses on Assatague. We call the horses wild, but the relationship between horses and people has always been a silent though prominent player in the story of the Assateague horses. It is easy, when on Assateague, to see the horses in the midst of this beautiful landscape and feel that you are in a wild, natural place, because there is no major development, no human residents, no fast food or television, no cellular towers and few of the trappings of the modern world. Apart from the automobiles used to transport visitors to the island and some utility poles to supply power to the ranger

LEFT: Having eluded the saltwater cowboys during spring pony penning, this pinto strolled around the wildlife refuge near the swan pool.
RIGHT: Map of Assateague and Chincoteague Islands. Courtesy of the National Park Service.

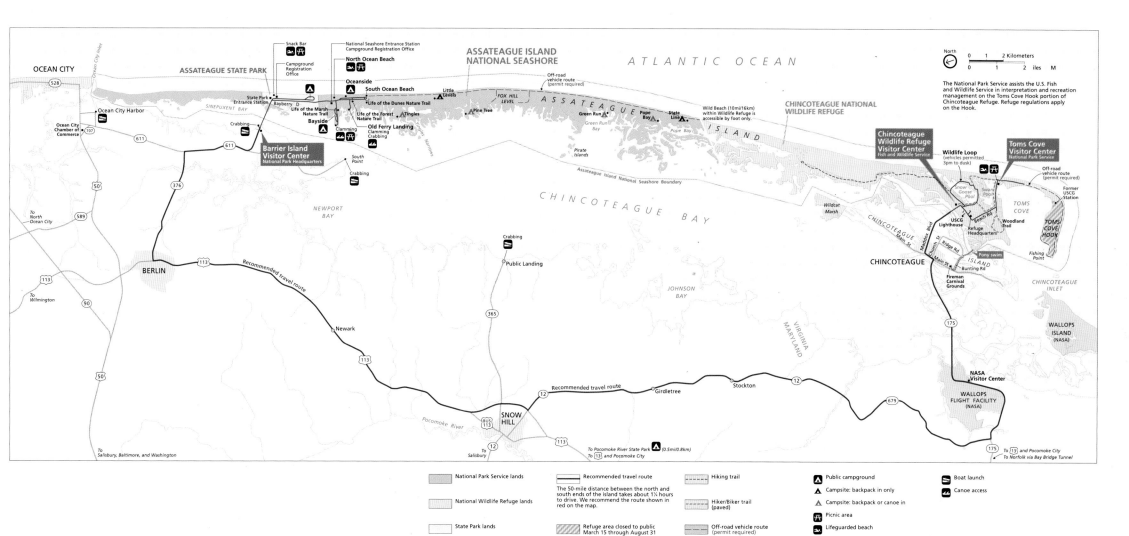

OCEAN CITY

ASSATEAGUE STATE PARK

ASSATEAGUE ISLAND NATIONAL SEASHORE

ATLANTIC OCEAN

North
0 1 2 Kilometers
0 1 2 iles M

The National Park Service assists the U.S. Fish and Wildlife Service in interpretation and recreation management on the Toms Cove Hook portion of Chincoteague Refuge. Refuge regulations apply on the Hook.

Snack Bar
National Seashore Entrance Station
Campground Registration Office
Campground Registration Office
North Ocean Beach
Oceanside
South Ocean Beach
State Park Entrance Station
Bayberry D
Life of the Marsh Nature Trail
Bayside
Clamming
Life of the Forest Nature Trail
Life of the Dunes Nature Trail
Old Ferry Landing
Clamming
Crabbing
Tingles
Pine Tree
Little Levels
FOX HILL LEVEL
Green Run
Pope Bay
State Line
Wild Beach (10mi/16km) within Wildlife Refuge is accessible by foot only.
Off-road vehicle route (permit required)
Crabbing

Ocean City Harbor
Ocean City Chamber of Commerce

CHINCOTEAGUE NATIONAL WILDLIFE REFUGE

Barrier Island Visitor Center
National Park Headquarters
South Point
Crabbing

SINEPUXENT BAY

Tingles Narrows

Pirate Islands

Assateague Island National Seashore Boundary

Chincoteague Wildlife Refuge Visitor Center
Fish and Wildlife Service
Wildlife Loop (vehicles permitted 3pm to dusk)
Toms Cove Visitor Center
National Park Service
Off-road vehicle route (permit required)

CHINCOTEAGUE BAY

NEWPORT BAY

Snow Goose Pool
Swan Pool
Beach Rd
Woodland Trail
TOMS COVE
Former USCG Station
TOMS COVE HOOK

Wildcat Marsh

USCG Lighthouse
Refuge Headquarters
Maddox Blvd
Main St
Church St
Ridge Rd
Pony swim
Bunting Rd
Fireman Carnival Grounds

CHINCOTEAGUE

Fishing Point

CHINCOTEAGUE ISLAND
CHINCOTEAGUE INLET

BERLIN

Crabbing
Public Landing

JOHNSON BAY

VIRGINIA
MARYLAND

Newark

To North Ocean City
To Wilmington
To Salisbury, Baltimore, and Washington

Recommended travel route

Recommended travel route
Girdletree
Stockton

SNOW HILL

Pocomoke River

To Pocomoke River State Park (0.5mi/0.8km)
To Pocomoke City

NASA Visitor Center

WALLOPS ISLAND (NASA)

WALLOPS FLIGHT FACILITY (NASA)

To and Pocomoke City
To Norfolk via Bay Bridge Tunnel

National Park Service lands

National Wildlife Refuge lands

State Park lands

Recommended travel route
The 50-mile distance between the north and south ends of the island takes about 1¼ hours to drive. We recommend the route shown in red on the map.

Refuge area closed to public March 15 through August 31

Hiking trail

Hiker/Biker trail (paved)

Off-road vehicle route (permit required)

Public campground

Campsite: backpack in only

Campsite: backpack or canoe in

Picnic area

Lifeguarded beach

Boat launch

Canoe access

INTRODUCTION

15

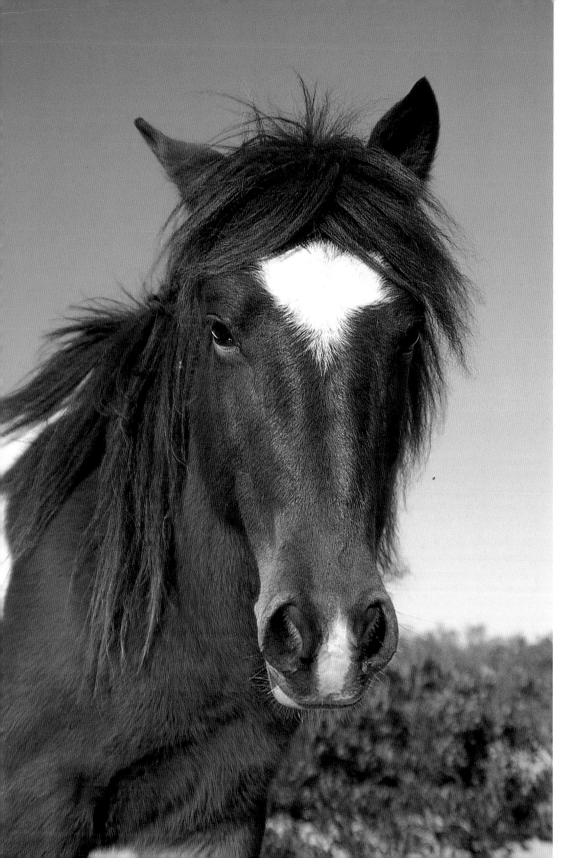
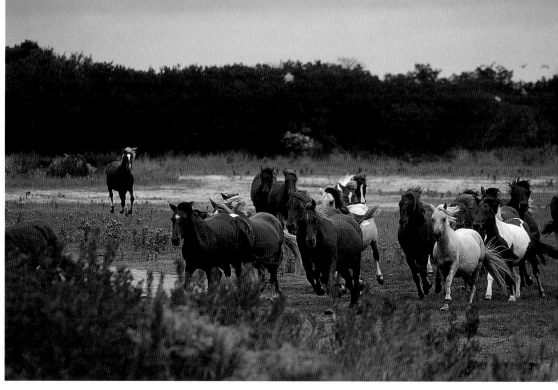
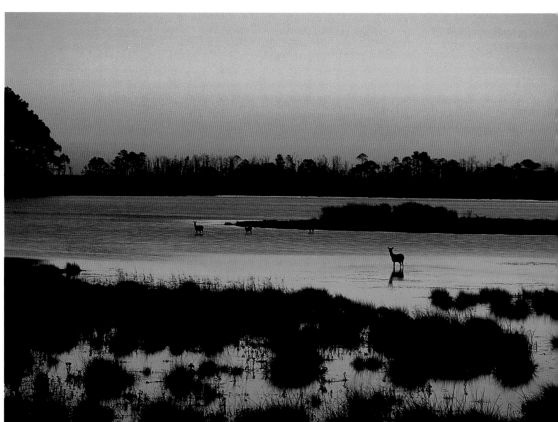

stations, there is very little civilization on most of Assateague. There are wooden walkways in the interpretive areas of the National Wildlife Refuge, markers for campsites in the camping areas, and some paved bike paths, but little else. If you move away from the main beach areas, you are even less likely to see many other people. During the summer season, this is more difficult, but not impossible. You look around and see shorebirds in the marshes and dragonflies whizzing through the saw cord grass. Dolphins can be seen swimming through the waves and pelicans flying over the surf searching for an easy meal in the shallow waters near the beach. You hear the sound of the ocean on the beach, even from the other side of the island. Perhaps you spy a six-point white tail buck eyeing you warily through the brush near the pine forest. Walking on the beach from October to March, you can go for miles and never see a soul. I once spent Christmas Day alone on Assateague in an icy winter wonderland, just the wildlife and me.

This is a wild natural place that nonetheless has seen millions of human footprints and once had human settlement, animal herding, and now tourism. Assateague has no permanent human population residing there, although it used to, before it became public lands. Residents of Assateague once made their living from the sea, mostly from clams and oysters. Their largest village was located approximately where the lighthouse stands, although when the village was there, this location was much closer to the ocean. Due to the natural movement of barrier islands from erosion, today the same spot is closer to the bay on the western side of the island.

When their access to the prime oyster and clam beds in Tom's Cove was restricted by the owner of the majority of the land on Assateague, the residents left the island, moving to Chincoteague. Many of them actually floated their homes across Assateague Channel to Chincoteague while a few others were just left behind. Occasionally, an old foundation remnant can be

LEFT: A curious pony.
TOP RIGHT: A group of horses running during spring pony penning.
BOTTOM RIGHT: Whitetail deer in the Chincoteague National Wildlife Refuge at sunrise.

seen in the woods; one is set next to one of the Park Service's interpretive paths in Maryland. Today, it is filled with water; its current residents are turtles and frogs.

Today, Assateague Island is uninhabited by people and the nearest community is Chincoteague Island, which lies just a quarter-mile west of the southern part of Assateague. The two islands are joined by a short bridge extending from Maddox Boulevard on Chincoteague. Because the islands are located at the southeast end of Chesapeake Bay, for generations the people of Chincoteague and the surrounding region sustained themselves from the sea. The watermen dug clams, scooped oysters and brought in fish for years, so much so, that by the end of the 19th century and well into the 20th, the name Chincoteague was synonymous with oysters. Indeed, the economics of the seafood industry at the time of the Civil War on Chincoteague, which was then a major supplier of seafood to Philadelphia, caused the island to be one of only two Virginia communities to remain loyal to the North during the war. The strategy proved successful. Afterward, Chincoteague shellfish were to be found up and down the East Coast. From the 1920s through the 1960s it was a Chincoteague firm that supplied the national A&P grocery chain with oysters and clams. Still today, wherever you go on Chincoteague, the parking lots are paved with oyster shells. Oyster shells were the foundation for the causeway connecting the island with the mainland. Then in the 1960s came the decline of the Chesapeake fishing industry, which included Chincoteague. Disease and overfishing set the stage. Then, government regulations put into place to help preservation efforts made it impossible to be profitable.

For a while, a new industry, chicken farming, grew and became a major economic force on Chincoteague. Poultry had brought prosperity to many communities on the mainland in nearby Maryland, so Chincoteague followed. One area of the island became known as "Chicken City" due to all of the long, low chicken houses found there, enough to produce one

million birds per year in the mid-1950s, which in turn was one-quarter of the island's chicken output. The poultry business on Chincoteague was knocked flat by one severe blow—the 1962 Ash Wednesday storm which killed several hundred thousand chickens and destroyed most of the chicken houses. The industry never recovered. While today there is no commercial chicken production on Chincoteague, there are nonetheless still hundreds of chickens roaming the island, and it's a rare location away from the business district that doesn't hear the crowing of roosters as every new day dawns.

Tourism, too, had long played a part in the region's economy. In fact, Assateague's northern end supported a resort hotel for well-heeled visitors as early as the mid-1800s.

One hundred years later, it was tourism that provided the impetus for enterprising Chincoteague businessmen to push for the construction of the bridge from the town over to Assateague. The pony swim had attracted media and tourist attention right from the start. In fact, it was a visitor from Illinois in 1945 who first told Marguerite Henry about the pony swim, which piqued the writer's curiosity enough for her to make the trip herself to learn more.

But the growth of tourism through the mid-20th century was slow in coming, and not nearly enough to immediately replace the economic losses from the downturn of the more traditional economic mainstays of fishing and agriculture. That would take more time.

With job prospects stagnating and no excitement on the island in the 1960s and 1970s the younger generations mostly left the island for school or to find less backbreaking work. By the late 1970s, the economic outlook for the island town was cloudy.

Fortunately, there were the horses.

While no people live on Assateague today, Chincoteague is an island town populated by approximately 4,500 permanent residents, with a summer population swelling to almost 10,000. After a series of fires in the 1920s the people of Chincoteague realized they needed a local fire department. To

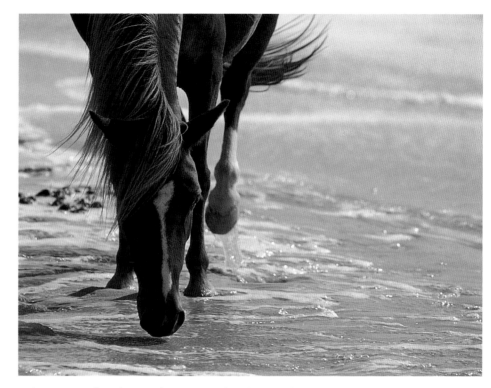

raise money for the equipment and training, the town held a carnival, much like firemen's carnivals everywhere. Except on Chincoteague, they came up with the idea of using the "pony penning"—the ancient practice of rounding up the horses on Assateague and swimming them across Chincoteague Bay to take them to "market," which in this case is an auction of the newborn foals from the wild horse herd to be held at the carnival.

It has been a grand success. The firemen have been able to raise the money they need, year after year, and keep the population of the wild horses on Assateague stable, but there have been additional consequences. By selling off foals from the Assateague herd at their annual fundraising fair, the Chincoteague firemen have managed to do a great deal more than just ensure the fire department's financial stability. They have created a tremendous tourism machine that has become the island's economic mainstay after the collapse of the fishing industry.

First brought to the attention of horse-loving girls nationwide through the 1947 publication of Marguerite Henry's classic children's book, *Misty of Chincoteague*, the pony swim and auction is now widely covered in the media. The television show *Good Morning America* broadcasts the event live, as do television networks from Europe and Asia. The day of the pony swim, Chincoteague's population grows more than five times its normal size. Indeed, for the last few years on pony swim day, over 50,000 people populated the island. It is an American phenomenon.

The swim is sometimes criticized as being overblown and circus-like, and perhaps not in the best interests of the horses. This is unfortunate, since what it signifies for the people of Chincoteague Island and the horses alike is the continuation of the relationship between humans and horses in a place where it might never have otherwise happened. That it happened there shows just how important that relationship can be.

Without the horses, the Chincoteaguers, whose economy was weakened by the demise of the Chesapeake fishing industry, could likely not sustain the middle-class existence they now enjoy. Without the pony swim and penning, it is very possible that the horses would have been removed from Assateague a long time ago either due to environmental issues relating to their interaction with other species there, or simply as a matter of population control. The people of Chincoteague were fortunate to recognize the value of the horses to their way of life. Their motive was undeniably financial—to raise the necessary funds to develop and sustain their fire company—but much more has developed between the islanders and the horses than economic exploitation. Like horse owners everywhere, Chincoteague loves its horses.

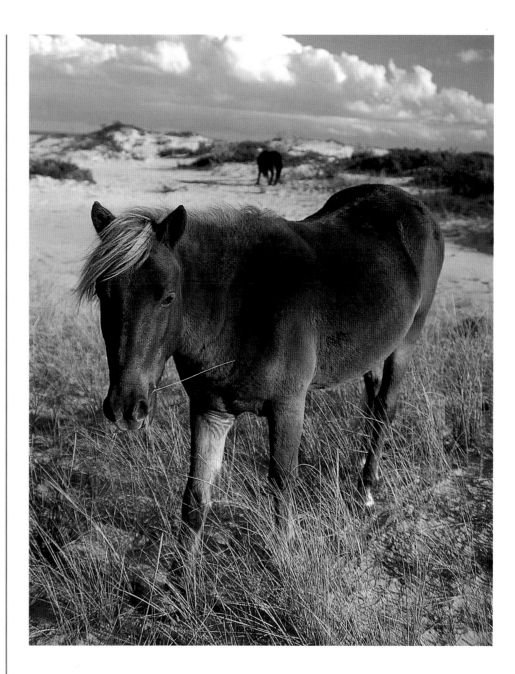

LEFT: During the heat of August, a horse seeks refreshment in a sip of salty seawater.
ABOVE: Its winter coat already forming, a curious pony munches on beach grass in early autumn.

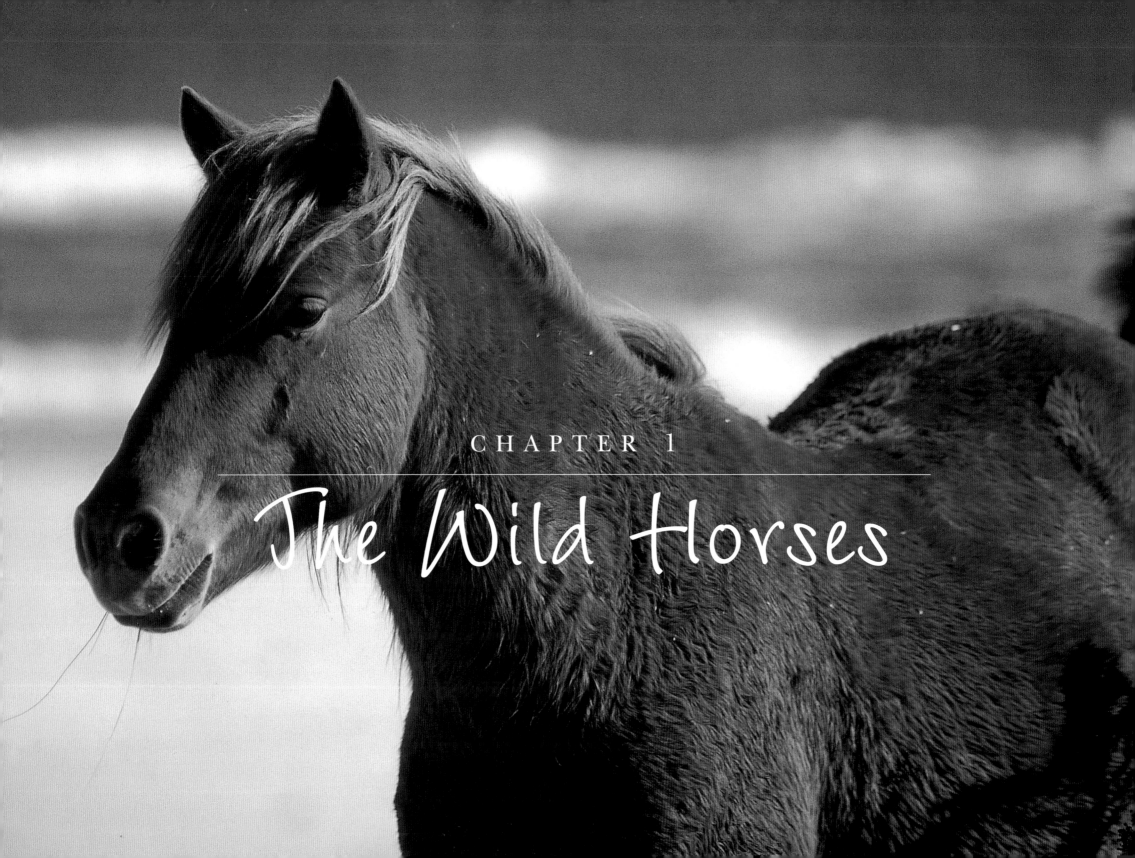

CHAPTER 1

The Wild Horses

The wild horses of Assateague are frequently referred to as ponies. According to the generally accepted convention, a horse that stands less than 14.2 hands, or 58 inches at the withers (just above the shoulders), is considered a pony. The Assateague horses are of varying sizes, some smaller than the official standard but many taller. The average height is between 12 and 13 hands, or about 50 inches, so they meet the size criteria. Their build is also very pony-like: Stocky, with short legs, square-ish muzzles and distinctive, thick manes. There have been many types of horses introduced into the herds on Assateague throughout the history, which affects their characteristics. Mustangs, Arabians, Welsh ponies and other horse breeds were introduced in attempts to replace stock lost during a disastrous storm in the 1960s and from disease in the 1970s. The introduction of other breeds has also helped strengthen the ponies genetically and resulted in a unique breed of horse. Life on Assateague is not easy, so the more diverse the genetic pool, the stronger the resulting animals will be as the characteristics necessary for adaptation and survival are chosen by natural selection. It is believed that a Welsh pony first introduced by Clarence Beebe (of *Misty of Chincoteague* fame) is responsible for the spotted coloration found in many of the horses. Before his involvement with the horses, their color was said to be mostly solid.

The reason the Assateague horses tend to be smaller seems to be attributable more to their harsh living conditions and limited diet than to anything else. They subsist primarily on the saw cord grass that grows in abundance in the saltwater marshes found everywhere on the island. Much of their food is salty, so they drink a lot of water, by some estimates twice as much as a domestic horse. They drink from water holes found throughout the island and directly from the salt marshes. I have seen them drinking salt water directly out of the surf, but only in small sips on very hot days. They also drink from the open water of the bay, which has a lower salt concentration than the ocean. The excess water retention caused by the high salt intake is why the ponies have large, round bellies.

They also eat poison ivy and thorn-covered green briar (to no apparent detrimental effect), pine bark, beach grass, and other native flora, which in combination provides limited, though complete sustenance. Because of the poor overall nature of their diet, the Assateague horses spend most of their time simply grazing, close to seventeen hours per day, just to sustain themselves. Visitors are often struck by how little activity they engage in. People expect to see the horses running, perhaps over the beach dunes, as in some romantic cinematic vision. Most people are surprised to learn that the horses rarely run on their own without some stimulus. A stallion may be chased away from the mares of another, and in the process he may trot a few yards then slow to a steady walk before stopping to grab a snack of nearby grass. Long, rousing gallops by even one horse, much less an entire herd, are quite unusual.

LEFT: A wild horse on the beach.
RIGHT: Nose of a wild stallion.

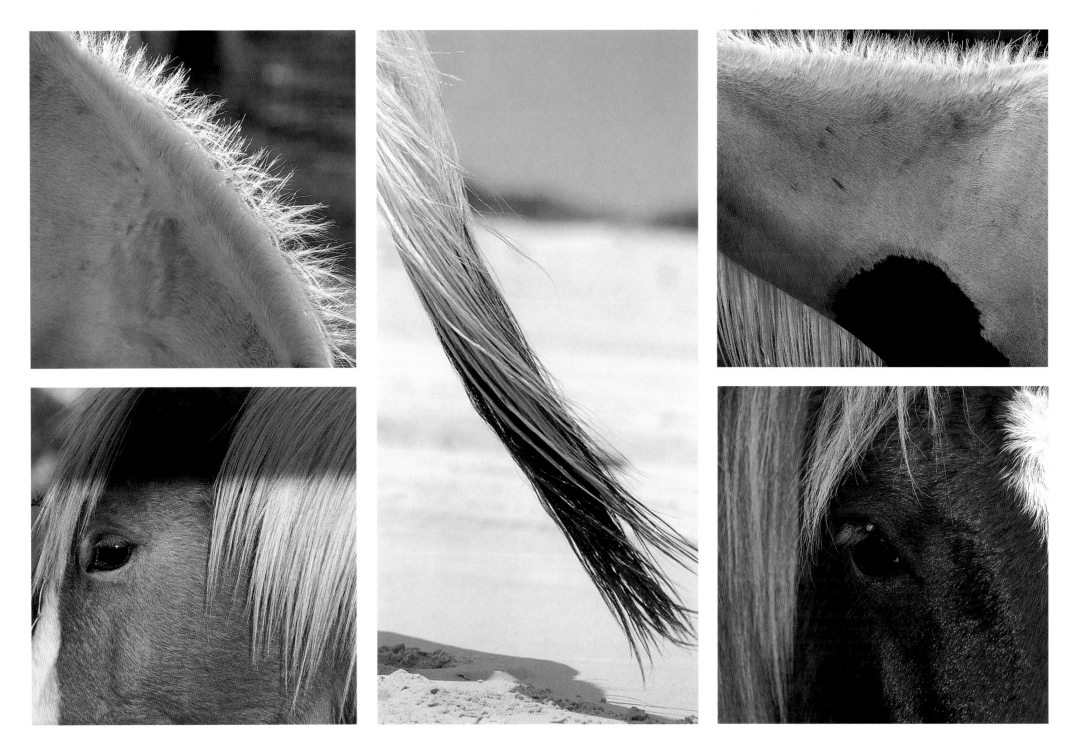

WILD HORSES OF THE DUNES

(Unless they are spooked, say by some two-legged visitor out for a few misguided laughs at their expense.) During the pony pennings, the horses will run when chased by the saltwater cowboys. Otherwise, most of the time they are quite placid.

There are good reasons for this. First, horses generally aren't interested in spontaneous running, unless they are trained to do so or are afraid for some reason. Being sensitive herd animals, if one (especially the dominant stallion) starts to run, the group will follow. But unless there is good reason to run, such as a herding cowboy or a predator chasing them, they will stop after just a few paces. Second, every calorie burned in physical activity has to be replaced. It takes enough time each day without running around for them to take sustenance from their environment. Running would simply exhaust them too much and this could lead to their demise.

Assateague Island is a barrier island, so-called since it acts as a barrier between the ocean and the mainland. As such, due to the constant pounding of the waves, the shape of the island is always changing. It is 23 miles long and sits approximately parallel to the coast of the mainland. There are many such islands found along the Atlantic coastline. There are two bridge accesses to Assateague, one at the northern end in Maryland and one near the southern end in Virginia. The border between those two states bisects the island. In the north, Maryland's Assateague State Park is reached shortly after you come off the bridge. The road turns immediately southward and soon enters the Assateague Island National Seashore area, administered by the National Park Service. There are wonderful beaches on the ocean side, and interpretive trails and campsites set up by the Park Service on the bay side. The road ends after a few miles, although with four-wheel drive and the appropriate permit from the Park Service, one can drive on the beach most of the way to the

TOP LEFT: A rare short mane catches the light.
BOTTOM LEFT: Late in the day.
CENTER: The long, multicolored tail is typical of the Assateague horses.
TOP RIGHT: A pinto's neck and long mane.
BOTTOM RIGHT: A stallion with a tick in his eyelid.

Virginia state line ten miles south. The east side of the island consists almost entirely of beautiful sandy beaches, well used by sunbathers, surfers and surf fishers, although never as crowded as the popular beaches of Ocean City, Md., with its boardwalk and summer-long carnival. Ocean City is just a few miles to the north of Assateague as the crow flies, but it's a million miles away (and a good 25-minute drive first west, then north and then east again) in human terms. The west side facing Chincoteague Bay and the mainland is a maze of coves, pine forests and marshland. Kayakers and some hardy back-packers find the west side of Assateague inviting and isolated, since there are no roads on this side of the island and off-road traffic is prohibited. Hunters come here to practice. Their blinds can be found throughout the western side of the island. Getting to the bay side of the island requires a lot of footwork and not a little bug repellent.

There is a fence at the state line, since there are different herds of horses in each state, each managed quite differently by different organizations. The Maryland horses are managed by the National Park Service, which runs the National Seashore, which stretches through both states. The horses in Maryland are left to their own devices for the most part. They are studied and watched, but not actually rounded up and given no veterinary care. They cannot be allowed to overpopulate the island, so they are given birth-control drugs through the use of darts, with a few individuals left fertile to reproduce and replenish the herd each year. In fact, the birth-control system was developed on Assateague as a pilot program for remote application of birth-control drugs in wild populations. The success of the testing here led to its more widespread adoption in other parts of the National Park System.

Horses in the Maryland herd that become sick or injured are left alone and may perish or recover as they will, without human intervention.

Visitors to the Maryland side of Assateague frequently see the horses roaming about the state park at the northern end, sometimes scavenging or begging for food. They are frequently found on or near the road, sometimes

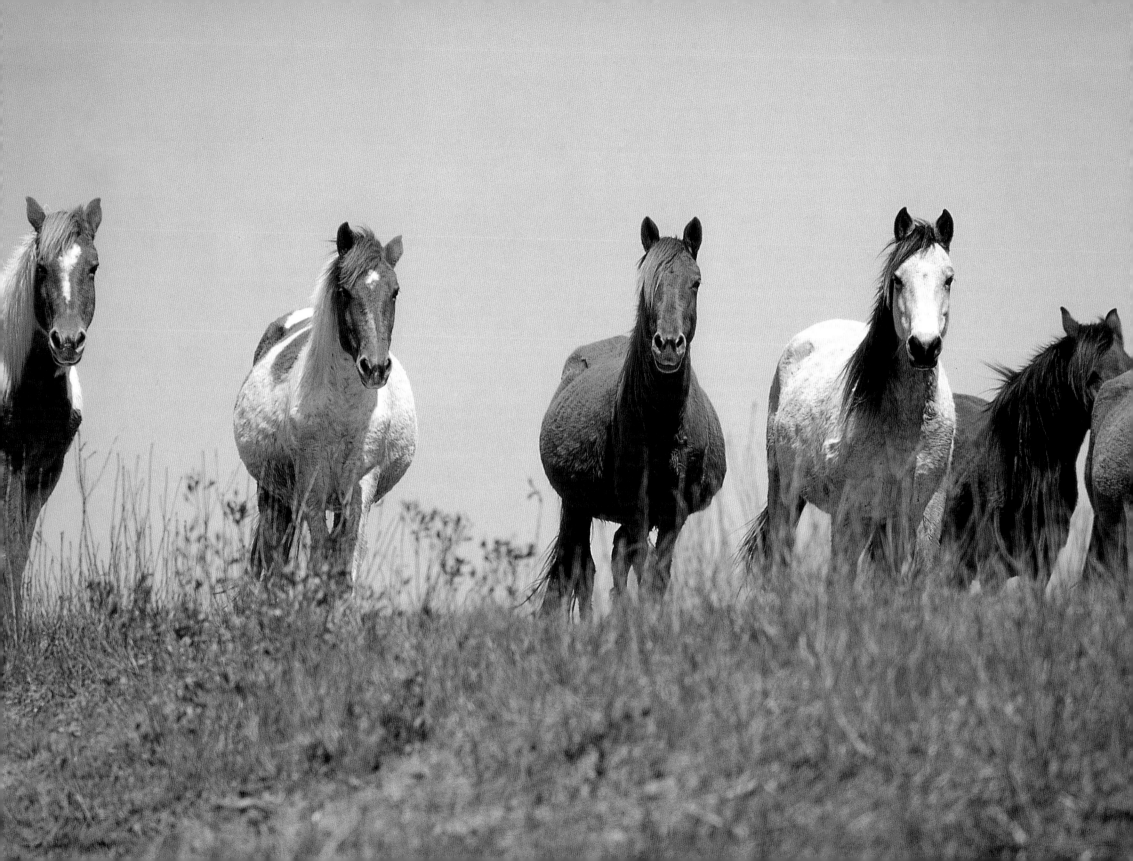

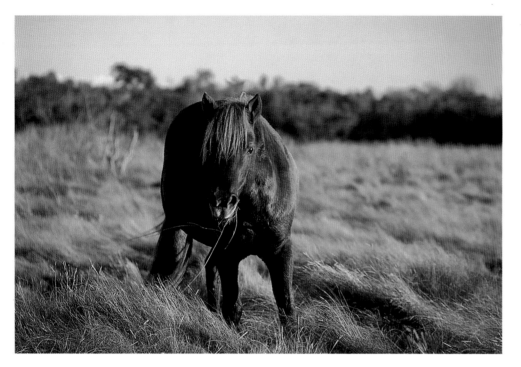

in the marshes near the access bridge or up at the northern tip just above the state park.

In my experience, most of the Maryland horses are afraid of people, but a few have become quite acculturated and will approach people, looking for a handout, an activity that is highly discouraged and illegal. It can even be dangerous. Despite the large and clearly posted signs warning visitors that these are wild animals that can and will bite or kick, there are regular reports of exactly that happening: a child or adult trying to feed a horse as if it was their pet ends up in the hospital getting treated for injuries received due to their own thoughtlessness. I have seen people reaching through their car windows to feed approaching horses; I have also seen them get ticketed by the Park Service. Injuries to people also occur when the horses engage in their own domestic squabbles, lashing out with a hoof or teeth without regard for any people or property that might happen to be in the way.

LEFT: A group of wild horses stop to take stock of approaching cowboys.
ABOVE: Eating grasses in the salt marsh.

Campers need to be careful how they store their food, since the horses can be quite persistent and aggressive in their search for easy calories. Some horses have been known to open closed coolers, looking for a snack. More than one camper has seen horses walk right through an upright tent on its way to a meal left on a nearby picnic table. Food left lying around is much more gratifying to them than the salty grass they usually eat, although eating food meant for humans will make the horses sick, since it is not part of the diet they are used to. Park employees have become diligent at keeping the areas free of food to limit the attraction of the horses to the camping areas. They also patrol regularly and keep people from encouraging the bad behavior of some of the horses.

There are frequently a few horses persistently looking for a handout, but I have found most of the Maryland horses to the south, in the off-road areas and away from people, walking in the pine forests or along the beaches. The park areas take up such a relatively small part of Assateague that it is extremely easy to get to the less visited parts of the island. If you stand on the beach looking inland to the west, you will see the dunes. Wait long enough on a warm day and you will see a horse or maybe a group moving slowly, browsing in the beach grass, moving from the scrub growth that is thicker on the other side of the dunes in the mostly flat area found running through the center of the island. From there, they will usually work their way onto the tops of the dunes, where, if you are lucky, they will remain for a while, allowing the breeze on that high point to provide some relief from the insects. With the off road vehicle permit, you can drive down the beach, and there are a number of turn-ins from the beach cutting through the dunes, which give access to this terrain. The horses are harder to find inland, since they tend to blend in with the larger plant growth. In many places, the salt marsh reaches through from the western side of the island all the way to this central terrain.

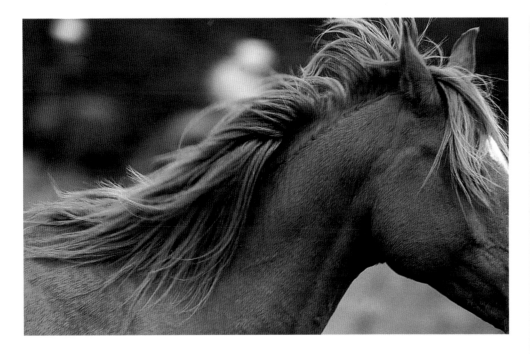

In the 1960s, before receiving its protected status, northern Assateague was targeted for significant resort development. A road was built all the way from the north end of the island down to the Virginia state line. Construction began but the project lost steam after the tremendous Ash Wednesday storm in 1962 destroyed all of the buildings, killed a number of horses, washed out the road and left doubts in the minds of the developers serious enough to cause them to help create the National Seashore instead. Remnants of the road still exist, running along the central interior of Assateague parallel to the beach, but in recent years travel along its path has been prohibited, so vehicular travel north and south along this road is not feasible. Storms wash the ocean over the dunes, making this road sometimes impassable anyway, but the Park Service has erected barriers, making vehicular passage impossible.

Many of the cutoffs from the beach continue across this central road and continue west, in a few cases through the salt marshes all the way out to Chincoteague Bay. They are there primarily for the use of hunters to access the best bird hunting locations. Numerous permanent blinds are located throughout the salt marshes. If you are inclined to visit one, bring several gallons of high-test mosquito repellent.

This is where many of the horses spend their time when they are not on the beach. The salt marshes are where their primary food source, salt marsh cord grass, is abundant. To the untrained eye, the salt marsh appears to be part of the bay, with long vistas of water; however the marsh is relatively shallow, maybe a foot deep, with a mucky mud bottom. The horses will walk out into it, enjoying the breeze that flows out on open water, eating the grass as they move along. A human walking through it will most likely lose his shoes in the sticky mud, be devoured by mosquitoes, and, once rescued, get into a heap of trouble from the Park Service.

Wild horses tend to have a home range area of anywhere from one to

TOP LEFT: A running horse's windblown mane.
BOTTOM LEFT: A mélange of shadows and equine necks.
RIGHT: One stallion fights off another, seeking to lure away one of his mares during pony penning.

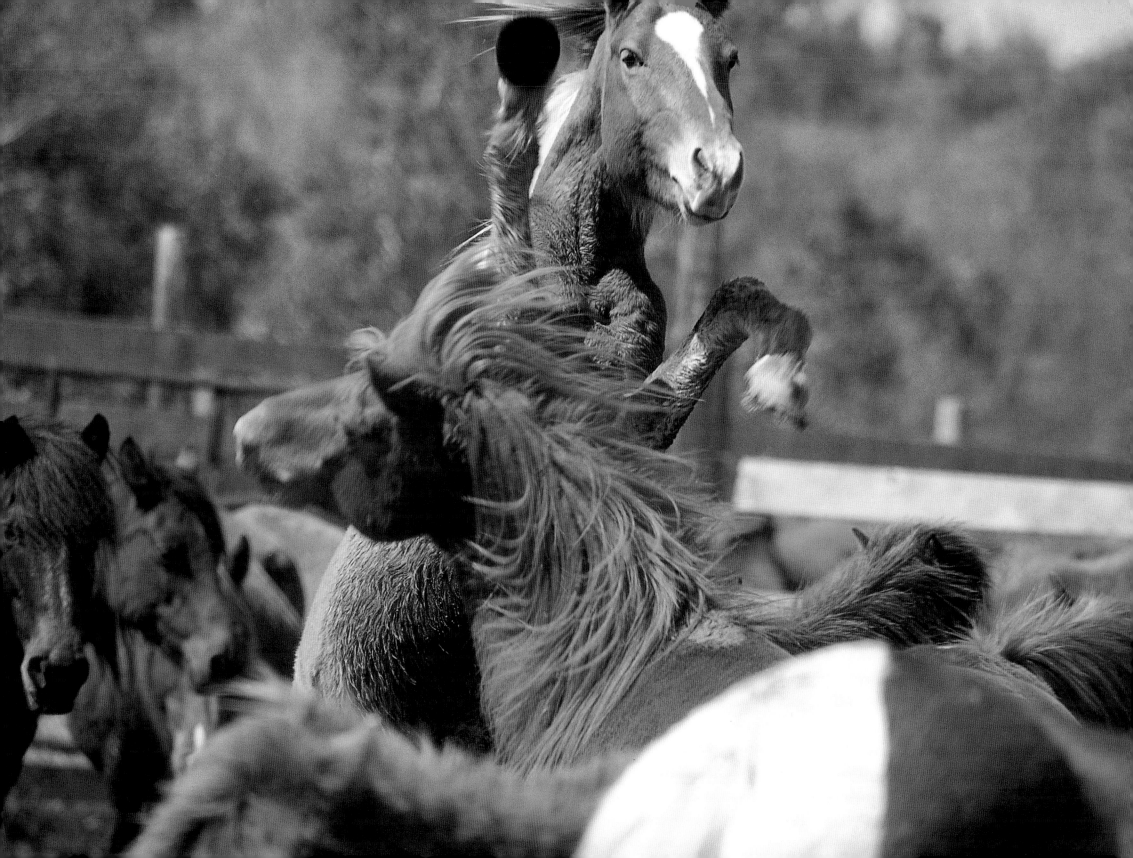

seven miles, as long as their food needs are met within the range. Therefore, along the thirteen miles of length and up to two miles of width of Assateague in Maryland, there is room for any number of groups to wander without much contact with people. Many never make it up to the park areas found at the northern end of the island.

For the most part, the horses are not openly afraid of people, but do not seek them out. If approached, they will usually walk away, perhaps moving to a trot to ensure escape. Anyone who spends time around horses will tell you that their sensitivity, both on a physical and on an emotional level, is extraordinary. Horses seem to know your mood before you even look at them. When learning to ride tame horses, beginners (with a good instructor) are taught to relate to the horse in certain ways that are designed to demonstrate to the horse that the rider is in control and is comfortable directing the horse. Otherwise, the horse will either not know what the rider wants it to do, or it will not care and it will then take control itself, which can be disastrous for a new rider.

In my experience on Assateague, the wild horses have only rarely been surprised by my being there, and that only has happened during bad weather with a strong wind blowing. Most of the time they know that I am there long before I know they are. I am never afraid of them, but I am always very respectful, and I believe that they sense this, and act accordingly. If they seem fearful or tense, I back off.

The horses will keep a consistent distance between themselves and approaching people, letting them know very clearly where the boundaries of their personal space lies. Family groups led by a stallion will be defended by their stud, who will charge you head-on if you get too close or appear threatening (in *his* view, not yours)!

The Virginia herd is managed very differently from the Maryland horses, although their behavior is the same. In Virginia, the horses are owned and maintained by the Chincoteague Volunteer Fire Department, whose pony committee is responsible for their care and whose members are known as the "Saltwater Cowboys."

Some of the *Misty* diehards will tell you that the Virginia and Maryland herds have actually evolved over the past forty years into distinctly different breeds of horse, which act differently from each other. This is silly. First, consider that some of the horses have been deliberately moved from the Maryland herd to Virginia over the years to help fill the respective herds after large losses from disease or storm-related deaths, and to remove some aggressive animals from the Maryland herd. Next, they have only been separated by a fence for a few decades, and it has been found on occasion to be somewhat porous, so there has been no absolute separation of the herds in the two states. Even if there had been, it takes more than a few decades for the genetic magic of natural selection to create a new breed of animal; despite the romantic dreams of aficionados of the children's story, that has just not happened.

The southern access to Assateague in Virginia is through Chincoteague, over a bridge into the Chincoteague National Wildlife Refuge (NWR), which is maintained by the U.S. Fish and Wildlife Service and in which bird watching is the number one activity. The Fish and Wildlife Service is a separate federal agency from the Park Service, which is in charge of the adjacent National Seashore. They each have visitor centers with interpretive materials and helpful, knowledgeable staff in the classic gray Smoky the Bear uniforms available to answer questions. There are also more beaches on the Atlantic side of the island. The NWR's roads and bike paths are heavily used through the warmer months.

Located directly on the Atlantic migratory bird flyway, the island is

TOP LEFT: A foal rests after running across Assateague to the southern pen.
BOTTOM LEFT: A wild foal.
CENTER: The long mane typical of Assateague ponies frames a stallion's face.
TOP RIGHT: A young foal seeking its mother's milk.
BOTTOM RIGHT: A foal nuzzling its mother.

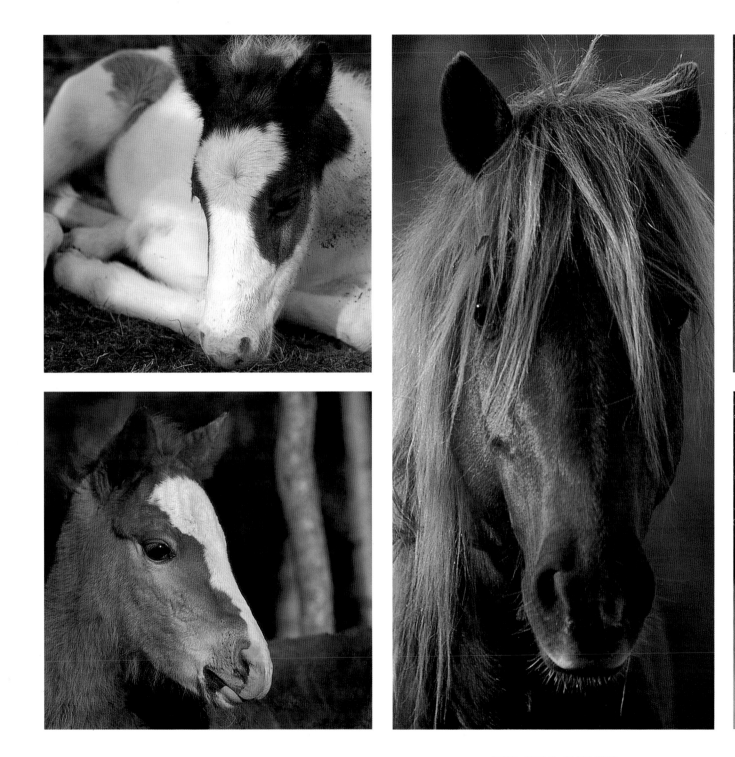
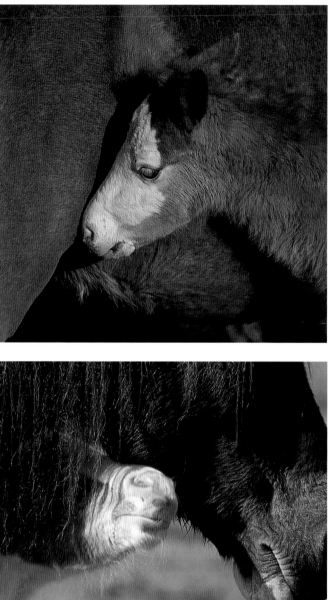

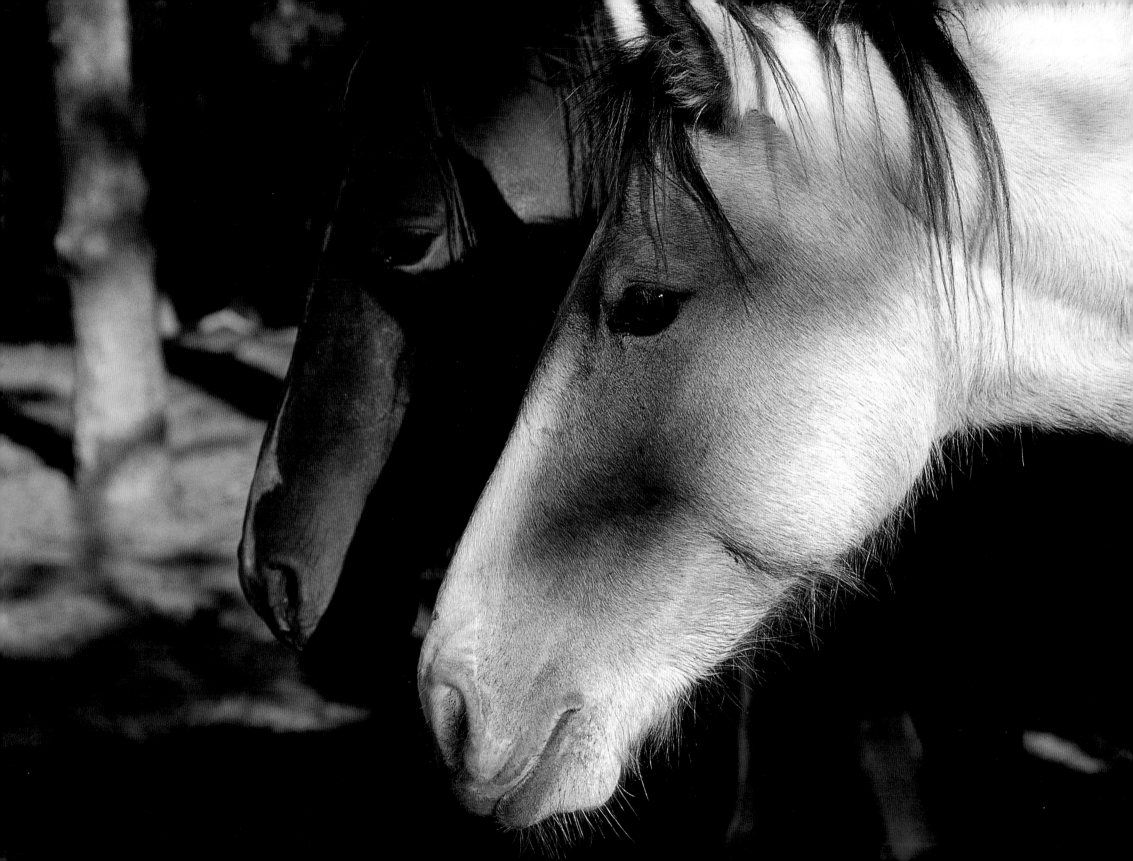

populated at different times of the year by many bird species. Visitors to the island include millions of birdwatchers annually, hoping to see their feathered friends passing through on their way north in the spring or south in the fall. From willets and herons, pelicans and plovers to ducks and geese of many colors, the island is a birdwatcher's paradise.

This is one of the most visited parks in the National Wildlife Refuge system. The area of the refuge most people see is a series of interconnected lagoons encircled by the access road into the refuge. The lagoons and the refuge are managed actively by the Fish and Wildlife Service, which has installed water-control structures throughout the refuge that allow them to control the water levels in the lagoons to make the habitat more attractive to the migratory birds. Being one of the top migratory shorebird staging areas on the East Coast, according to the Chincoteague NWR website, it is a "vital resting and feeding spot for a large number of and diversity of birds." It is a natural area that has been artificially enhanced by the government to promote

LEFT : Tan buckskin and dark brown horses in profile.
ABOVE: Foraging in the pine forest in autumn.

the environmental goal of protecting and supporting migratory shorebirds. It has been designated a World Biosphere Reserve by the United Nations Educational, Scientific and Cultural Organization.

Because of the importance of the birds and the sensitivity of the Fish and Wildlife Service to the sometimes competing needs of the birds and the horses, the horses are much less visible at the southern end of Assateague in Virginia. To keep the horses away from the birds, they have been fenced off, mostly in areas not accessible to the general public. In addition to the major species that pass through the refuge, there is at least one endangered species: the piping plover. These birds make their nests on the ground. The horses may be wild, they may be natural creatures, but they are not sensitive environmentalists. They go wherever their stomachs tell them to find food. When they were found to be damaging the ground-nesting habitat of the plovers, a hue and cry was heard from the bird-watching community. After much discussion and conflict, the firemen and the government agencies arrived at the compromise of keeping the horses restricted to certain parts of the refuge, where they remain. Their numbers are restricted to 150 animals in Virginia, with optimally the same number in Maryland.

Putting the horses behind fences served another purpose: Preventing the same problems with acculturation that exist up in Maryland. The horses can be viewed from a distance in certain parts of the refuge but not approached by visitors. The result is that the Virginia horses are much more wary of two-legged creatures than their Maryland cousins. This is certainly to their benefit.

In the wild, the horses tend to congregate in groups. Family groups consist of a stallion who dominates, a number of mares with whom he mates, and their offspring. Only the dominant male in a group mates with the females. Other males, usually offspring of the dominant stallion, must leave the group and find their own females to mate. Male horses typically leave the group after a few years to seek out mares of their own. Some groups consist of bachelor males who have not yet found females with whom to mate. The

dominant stallion of any particular group does not take kindly to other males making advances on his harem.

There are also some individual horses that roam on their own, unattached to any group. These are usually unattached males, but some are older females who have finished having offspring; others may just not get along with other horses.

Sometimes they travel in groups of two or three, bachelors without mates, perhaps they are siblings or just loners who team up until one finds a mare with which to begin a new group.

When approached, the horses will look up at the visitor, frequently with grass sticking out of their mouth, which they continue to chew, eyeing the newcomer curiously before bending to take another bite. Eating is their primary occupation and it takes more than mere curiosity to interrupt a meal. If the visitor appears threatening or moves closer, the horse will move away, slowly at first but if startled, it will simply bolt, moving roughly through whatever obstacles are in his way. Since the island is flat and covered with plant material, obstacles are few. The horses will move into and through marshes, thick brush or eight foot high stiff saw cord grass with much more ease than I ever could. It is their world, and they are comfortable moving in it.

It is not easy for a lone stallion to find a mate. Stallions with harems tend to be very protective. When a single stallion approaches a group dominated by one male, the male will put himself between the group and the newcomer. He will continue eating, and to the uninitiated observer the entire scene will look no different than before the visitor had arrived. It may not appear obvious unless one is watching for it, although a hopeful single stallion no doubt notices. If the interloper comes too close, the defender may charge, although it will be just a few steps in his direction. Most will back off at this point, but a daring hopeful with enough motivation will stand his ground. The defender will approach. Each will sniff around the head of the other, and the tension will rise. Tails will swish, but they remain otherwise motionless. Then suddenly,

one will bite the neck of the other and front hooves will be stamped as the bite is returned amid snorting and scuffling.

If the marauder does not turn away then, one of the males will rise up and tear the air around the head of his rival with his front hooves, kicking. One or the other will turn to deliver a kick from the rear hooves. If this still has not driven the new male away, then the entire routine will repeat itself, until a victor emerges. This stallion then approaches the females who have remained not far, watching and actually still eating!

The mares in Virginia, not constrained by the birth-control drugs applied to their Maryland cousins, can go into heat again relatively soon after delivering, once the foal has stopped nursing, resulting in a succession of pregnancies. Consequently, the Virginia herd has a relatively high foaling rate, meaning that approximately 75 percent of the mature mares have foals each year, whereas in a normal wild horse population, including the Maryland herd (before birth control was introduced) the rate is closer to 45 percent. This is most likely because the Virginia foals are weaned earlier than is usual for horses. Mares, like other female mammals, do not ovulate while they are lactating, which ceases when the newborn is no longer nursing. Remove the foal from the mother, her milk stops, and ovulation recommences, allowing her to become pregnant once more. The firemen also sell more colts than fillies, with more of the turnbacks being females that can produce yet more offspring. Coupled with the high foaling rate, this is a good thing for the fire department's fundraising efforts, not to mention more stud opportunities for the stallions, but one wonders how good it is for the poor mares. Recognizing this, one local woman only half-jokingly remarked to me that for this reason, if there is such a thing as reincarnation, she would make a deal with the devil to ensure that she does not return as a mare on Assateague.

RIGHT: Horses benefit from the fly-swatting utility of each other's tails. Sometimes they groom each other in this position, biting bugs off from the places unreachable by the host animal.

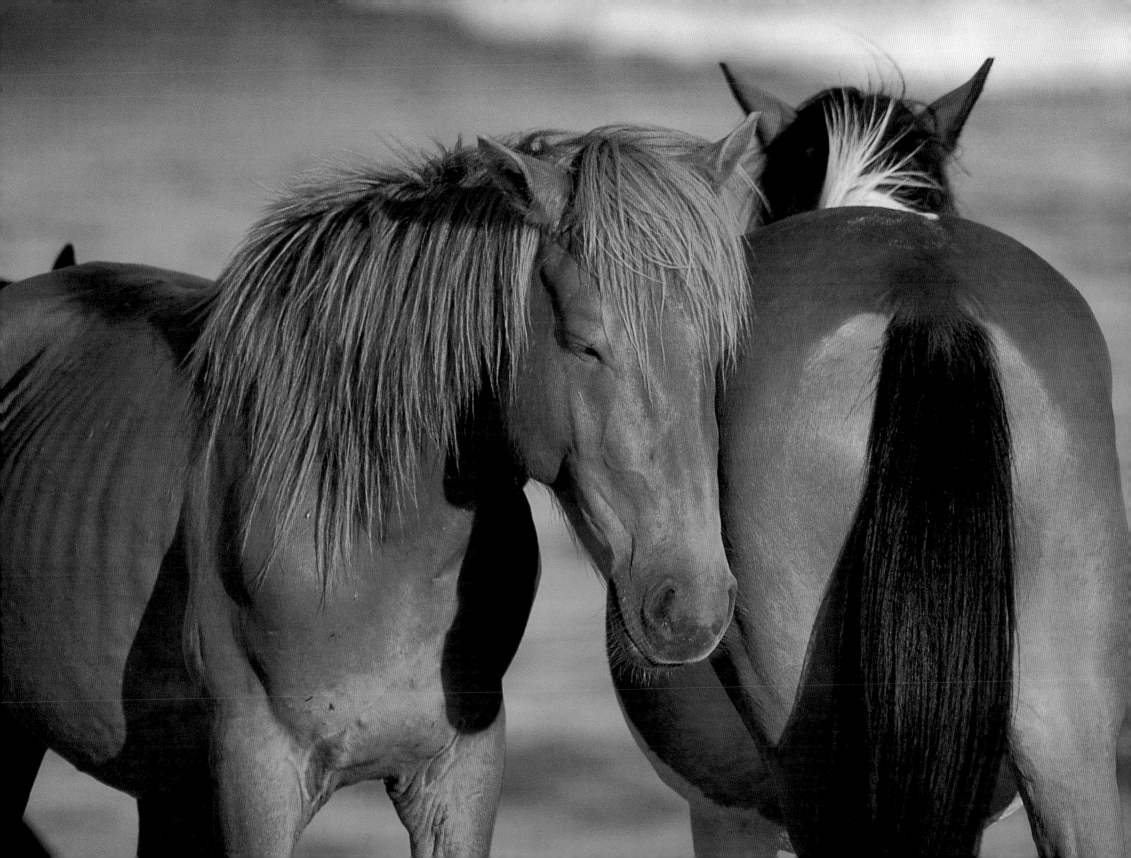

The Saltwater Cowboys

While the roots of the horses are debated, no dispute surrounds the origin of the famed "Saltwater Cowboys." The Chincoteague Island Volunteer Fire Department takes great pride in its stewardship of the horses that occupy the Chincoteague National Wildlife Refuge on the southern part of Assateague Island in Virginia. Their efforts are rewarded annually by tremendous media attention, which is expertly managed by these small-town working men and women during "pony penning week" in July. Cultural descendants of the herdsmen who kept their livestock on Assateague, rounding them up for periodic auctions, the firemen came upon the pony swim and auction idea back in the 1920s when two devastating fires left cash-strapped Chincoteague in need of effective firefighting apparatus. Chincoteague Island lies more than three miles from the mainland. Before the advent of the automobile, travel by boat to the island was the only means of travel between the island and the mainland. By the early 1920s, a causeway over the marshlands and water that lie between Chincoteague and the mainland was built. When the fires of the 1920s struck, the slow communications and mobility of the era forced the town to wait for help to come from mainland, resulting in enormous damage. Once the vulnerability of the growing community to fires was revealed, the townspeople realized they could not tolerate the status quo. They needed a reliable, well-funded fire fighting company on Chincoteague Island. The problem was that they did not have the money to pay for one.

A simple but brilliant plan was developed. Everyone was familiar with the pony pennings every summer. The firemen decided (like fire companies everywhere) to raise funds by holding a carnival during the pony penning. They also revived the practice of swimming the horses from Assateague to

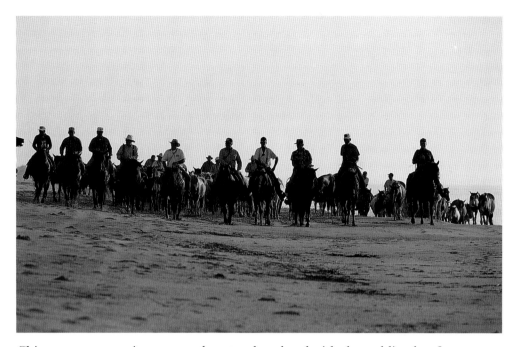

LEFT: Saltwater cowboys herding horses on the beach on Assateague Island.
RIGHT: Monday morning before the pony swim, the firemen bring the northern herd south to join the southern herd. On Wednesday, the horses will swim.

Chincoteague, a unique event that struck a chord with the public, that from the very first carnival and pony swim in 1925, turned out to watch. Even in the late 1920s and early 1930s the pony swim was filmed for newsreels and covered by national media. Today, it can be watched on television shows like *Good Morning America* and live on the Internet. Media from countries all over the world broadcast it to their home audiences. I have seen Polish and Japanese television networks filming there, as well as film crews from all over the US. There was a crew from Animal Planet at the 2003 event.

Encouraged by their early success, the firemen acquired their own herds of horses on Assateague, and in the 1940s when the National Seashore administered by the National Park Service was established on Assateague, they worked out an arrangement with the Park Service and with the Fish and Wildlife Service to own and maintain the horses in the Chincoteague Wildlife Refuge.

The firemen take their responsibility for the animals very seriously. Considering the extent of their investment in the horses, not to mention

their love for the animals, it's no wonder that they work as hard as they do to ensure that the horses stay healthy, while at the same time not interfering with their day-to-day existence out on Assateague.

Cowboys and their families will tell you who their favorite horses are and why. Perhaps a tall chestnut stallion with a black mane is just too pretty not to admire. A particular mare may have foaled some beautiful babies over the years that fetched good prices for the fire department at the auctions. Or maybe a horse just has personality and spunk. One stallion, a tall, muscular, brown horse with a blond mane and wild blue eyes (with the unlikely but appropriate name of "Surfer Dude"), is admired by the women like a rock star. Apparently, the mares feel the same, as he reigns over a harem that fluctuates between six and nine females.

The summer pony penning and swim is not the only time the firemen round up the horses. They conduct two off-season roundups, one in the autumn and again in the spring. In Virginia, the horses are divided into two groups, called the northern and southern herds. The firemen gather on Assateague at sunrise for two days, rounding up the southern herd one day and the northern herd the next. The southern herd is the one seen by most visitors to the refuge, and they are brought to the pen on the main beach road. Occasionally during the roundups, a stray horse or two is seen on the main access road into the refuge, where they are normally not allowed to be. The cowboys quickly round them up.

The next day, the saltwater cowboys drive a caravan of trucks with their horse trailers through the refuge up the restricted road north past a pen just north of Carr's Marsh and continue north until the road ends at a cul-de-sac

LEFT: Bobby Lapin pumps water from the troughs in the southern pen. During the hot summer, the horses drink gallons of fresh water while in the pen, requiring the firemen to keep the troughs full.
RIGHT: For over seventy years, the Chincoteague Volunteer Fire Department has been swimming the wild horses over from Assateague Island and selling the foals to raise money to keep the company equipped and trained.

they call the "turntable." From here, they ride to the Maryland state line and then move south, gathering the horses of the northern Virginia herd. Volunteer helpers and family members bring their trucks and trailers back to the pen, shuttling back and forth carrying drivers in the backs of their pickup trucks until all of the trailers have been collected. During the summer penning when the mosquitoes are thick, the pickups have to keep moving, lest the volunteers riding in the open back become sitting ducks for the hungry insects. They use plenty of repellent, but no one enjoys swatting away the bugs even if they are not biting.

For each of the roundups, the men (and all the riders are still men, at least 16 years old since that is the minimum age to be a member of the fire department) ride for hours, seeking out the groups and individual horses, herding them south through the marshes and over the beach to the pen. Rain or shine, cold or hot, the saltwater cowboys get the job done. There are frequently one or two rogue horses that refuse to come in with the herds. The cowboys continue trying until they corral them, riding late into the

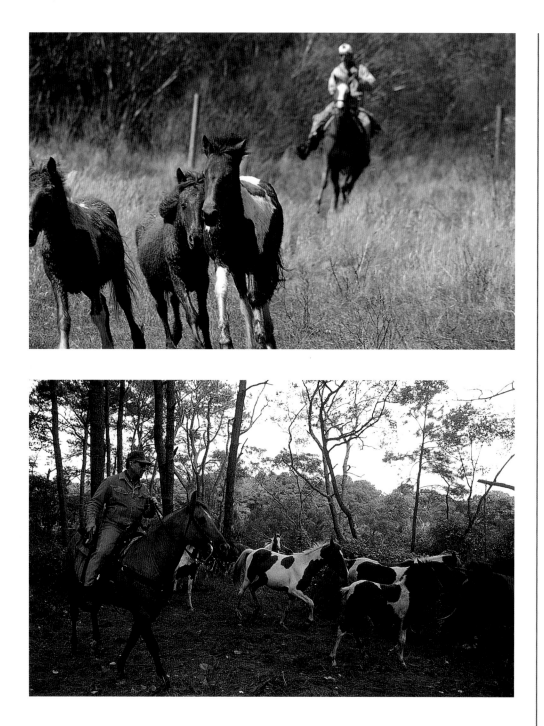

evening sometimes, wet, tired and hungry, usually with the stubborn creatures in tow.

These roundups are a time of great camaraderie for the cowboys. Not all live on Chincoteague: Some live on the mainland nearby; many are former islanders who moved away to find work. In years past, the cowboys were known for being pretty rowdy on the roundups, a tradition that has for the most part been left behind. But there is no doubt that these men still have a great time out there. The roundups are a time for catching up with old friendships and meeting new families. They talk about business, their horses and their loved ones. They trade old war stories and pass them on to the younger riders. They play practical jokes on each other and tell tall tales. Some of these men have been riding together for decades. Herman Daisy stopped riding in 2002 at the age of 84. Butch Peters stopped riding after 46 years because of back problems; he had started when he was 15. My friend David Cherrix still rides at age 69; he began when he was 13, and except for the years he was overseas in the service, he has made it to most every pony penning since. So has George Foskey, the oldest rider in 2003 at the age of 76. George helped round up the northern herd on Sunday, a terrifically hot and humid day, regaled us with stories over lunch with his usual enthusiasm and great cheer, then that night collapsed from heat exhaustion. He was released from the hospital the next day, and cheerfully rode in the pony swim on Wednesday nonetheless, looking none the worse for wear. George, who has attended 47 years of pony pennings, likes to say that if he had a dollar for every mile he has ridden on Assateague, he would be a millionaire. "It's a lotta miles and a lotta work!" He wouldn't trade it for anything.

THIS PAGE TOP: Bringing in three stray horses during one of the off-season roundups.
THIS PAGE BOTTOM: Rounding up the southern herd in the pine forest near the woodland trail during spring roundup.
LEFT: The cane and the rope are tools used to herd the horses.
TOP RIGHT: Whips carried by many of the cowboys are snapped to move the horses; they are not used to strike the animals.
BOTTOM RIGHT: Ropes come in handy, especially for bringing in a recalcitrant stray animal.

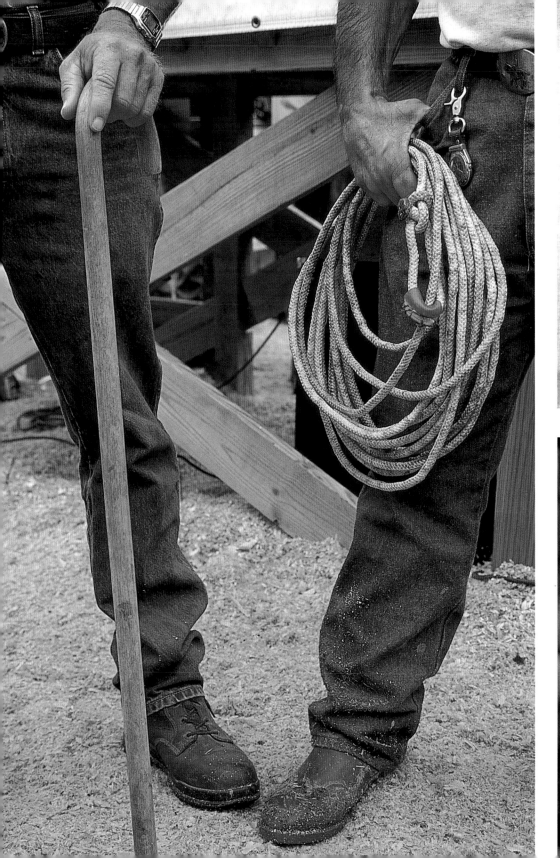

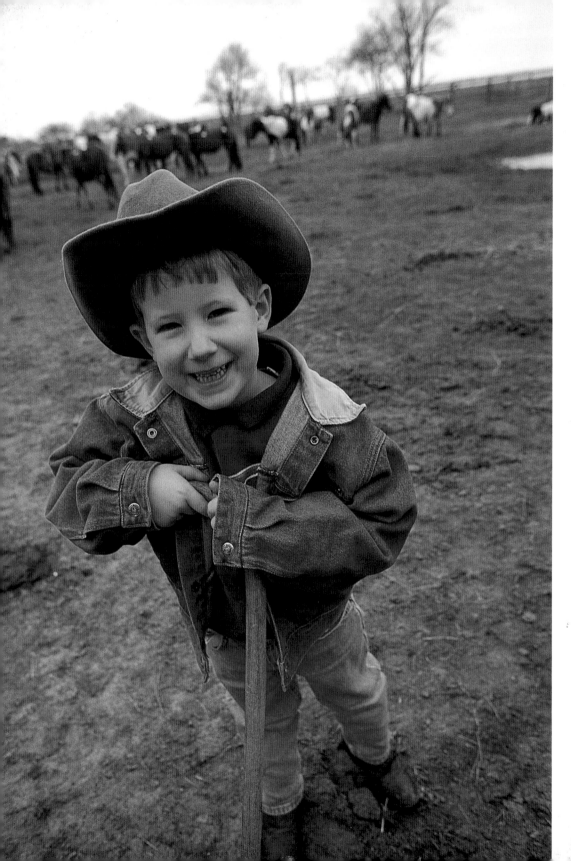

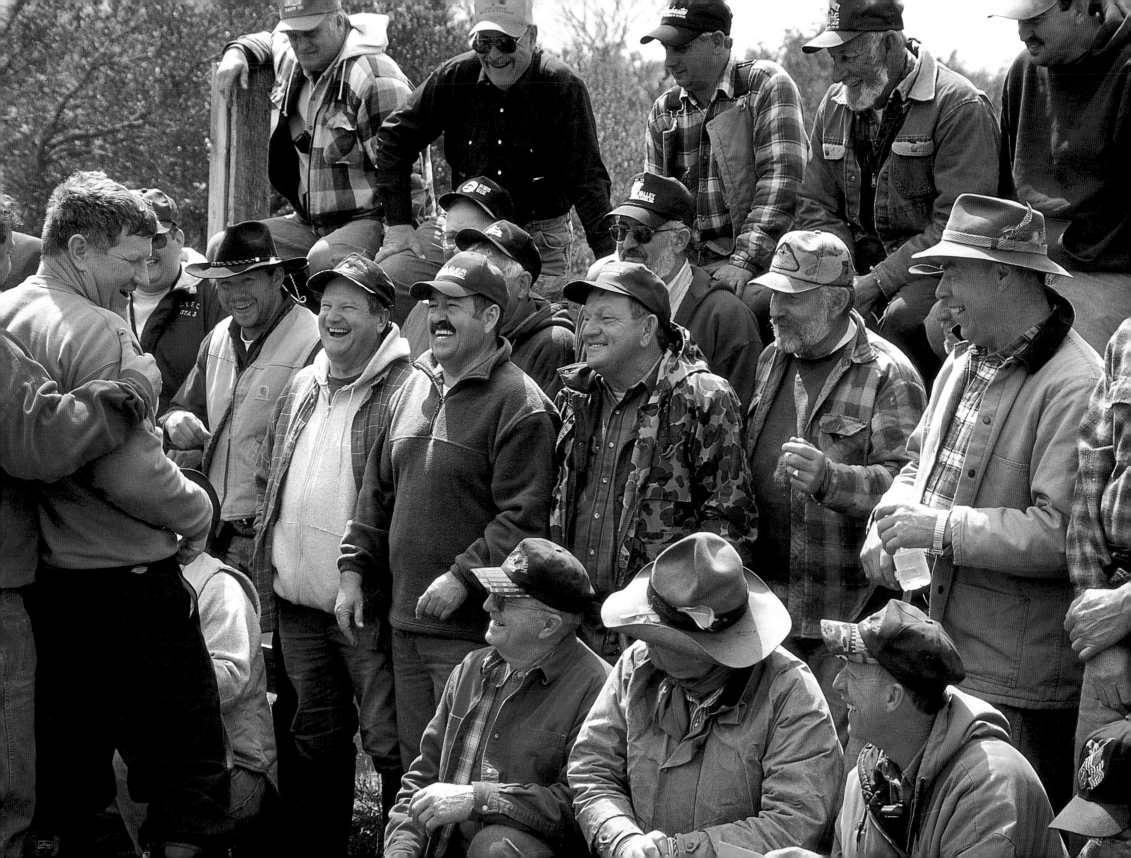

Not only must one be a member of the fire department to ride, he also has to be an expert rider. The horses run on the beach, in marshes, through streams and over rocky terrain. Accidents do happen. Or sometimes the horses just won't cooperate.

Back in the early 1980s, a particularly stubborn dark bay stallion named Broke Jaw eluded the cowboys for four years. One year, he was chased through much of the day without success. When cornered, he knocked one cowboy off his own horse and fled, plunging into Chincoteague Channel, where he swam across to Tom's Cove near the usual swim point. He was finally caught on Chincoteague and put into a pen with other horses. In the pen, he mated with three mares, then jumped the fence and swam back across the channel to Assateague.

Usually, though, the cowboys have herded the horses by lunch, which is served by the families and a few firemen who don't ride. Some are retired from riding because they can't ride for health reasons, or they are too young. The wives and daughters get into the act, feeding their men. Some of the women are full members of the fire department; others are simply helping out.

Once in the pen, the horses are led through a series of corrals into a narrow fenced passageway, or chute, to be looked at one at a time by a veterinarian who administers shots (some of which are required by law) and other necessary medicines and treats other health problems that might arise from the animals' feral existence. These horses do not wear horseshoes like domestic horses, so some hooves grow distended from lack of hard surfaces to wear them down. Fights among males, a stumble into a hole, infected insect bites or any number of mishaps can require care. Most problems are left to heal on their own, but the vet is there for those who need him. The fire department spends many thousands of dollars on veterinary care each year.

Each horse kept with the herd is branded with the year of its birth, which helps the firemen and the Chincoteague Pony Association keep track of their

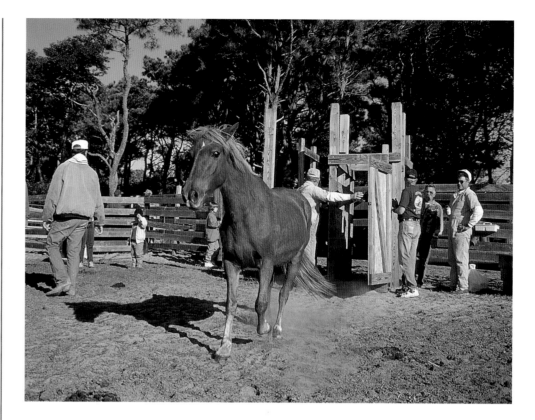

PAGE 40 LEFT: Tyler's daddy has been riding on Assateague for over twenty years.
PAGE 40 RIGHT: Firefighter Stephanie Belton.
PAGE 40 BOTTOM RIGHT: Chincoteague native David Cherrix has worked the pony swims since he was a teenager in the 1950s.
PAGE 41: After the penning, the saltwater cowboys enjoy a light moment while posing for a group photo.

ABOVE: A horse trots out of the holding chute used for a veterinary check.
TOP LEFT: Saltwater cowboys caring for a dehydrated horse. Weak, old, and very young horses are not swum with the herd.
BOTTOM LEFT: In the chute, waiting for the vet.
CENTER: Veterinarian Charlie Cameron administers oral vaccine.
TOP RIGHT: Checking out the first horses brought into the pen during a wet spring roundup.
BOTTOM RIGHT: Giving an ear scratch to an old friend, Naomi Belton keeps track of the horses and their foals for the fire company and the Chincoteague Pony Association.

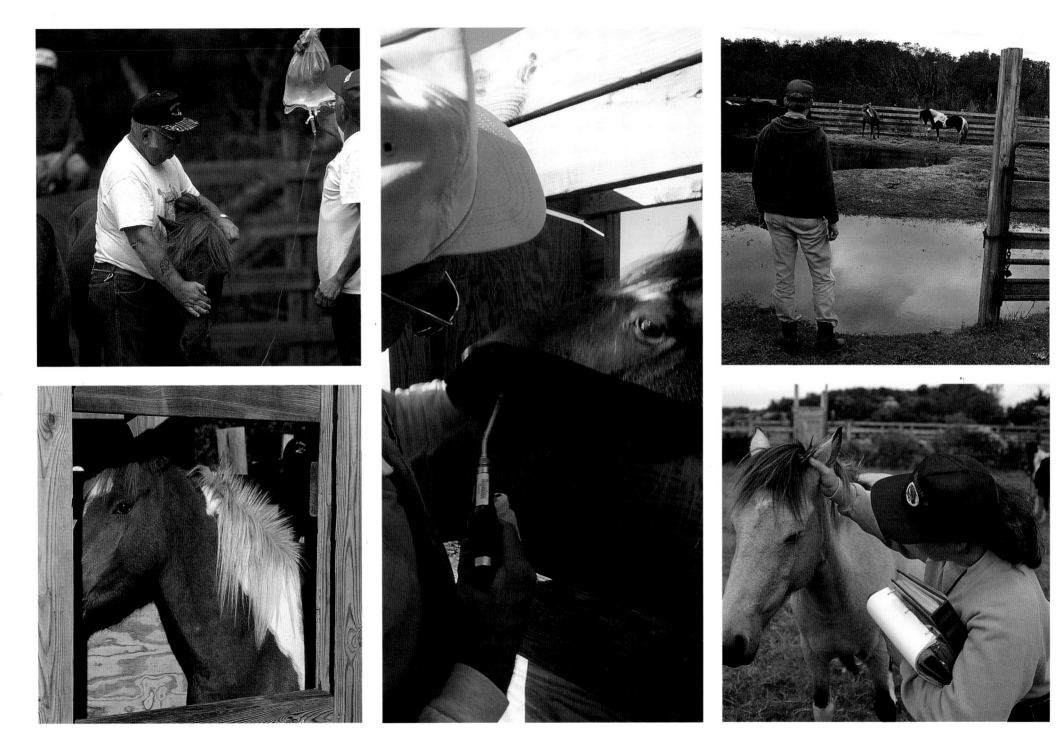

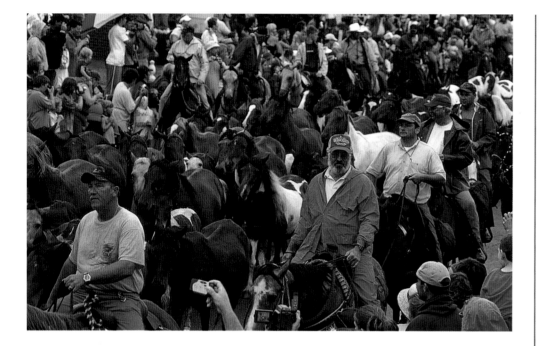

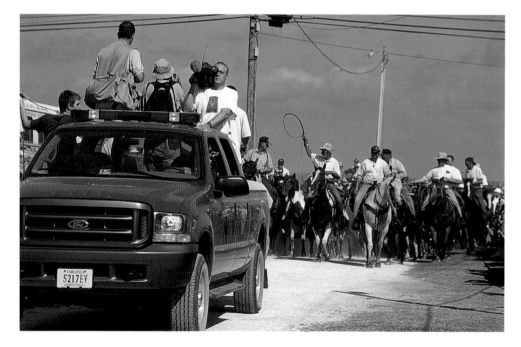

age. A photo registry is also kept by the association, which helps them keep track of lineage and bloodlines of the horses, which is important since the horses are a recognized breed. Owners of the horses sold at auction are asked to register their horses and also to keep in touch and provide registration information when they breed their animals to track the bloodlines. They have found that the value of the horses has remained strong at least in part due to the work of the association.

The records also help them keep track of vaccinations, and other information particular to each animal.

The autumn roundup prepares the animals for the hard season ahead. The firemen take stock of the horses and bid them farewell. Over the winter, the horses are mostly on their own. In a very hard winter, the firemen may go out onto Assateague and break the ice that covers water holes or leave some hay out, but for the most part, there is no interaction between the horses and the people.

In the spring, the firemen anxiously check the mares for pregnancy, and greet new foals like newborn babies brought from out of town by visiting cousins. The spring roundup is, like springtime itself, filled with the air of anticipation, for it is at the spring roundup where the firemen see the state of the animals they will be presenting to the world at the pony swim in July. The spring roundup bears the seeds of a successful summer pony swim, with the auction of the foals and the carnival.

TOP: An hour after the pony swim, the saltwater cowboys parade the wild horses through the town of Chincoteague. Main Street is jam-packed with spectators, cowboys, and horses.
BOTTOM: The event is seen around the world on TV and on the internet.
RIGHT: The cowboys surround the wild horses as they herd them through town.

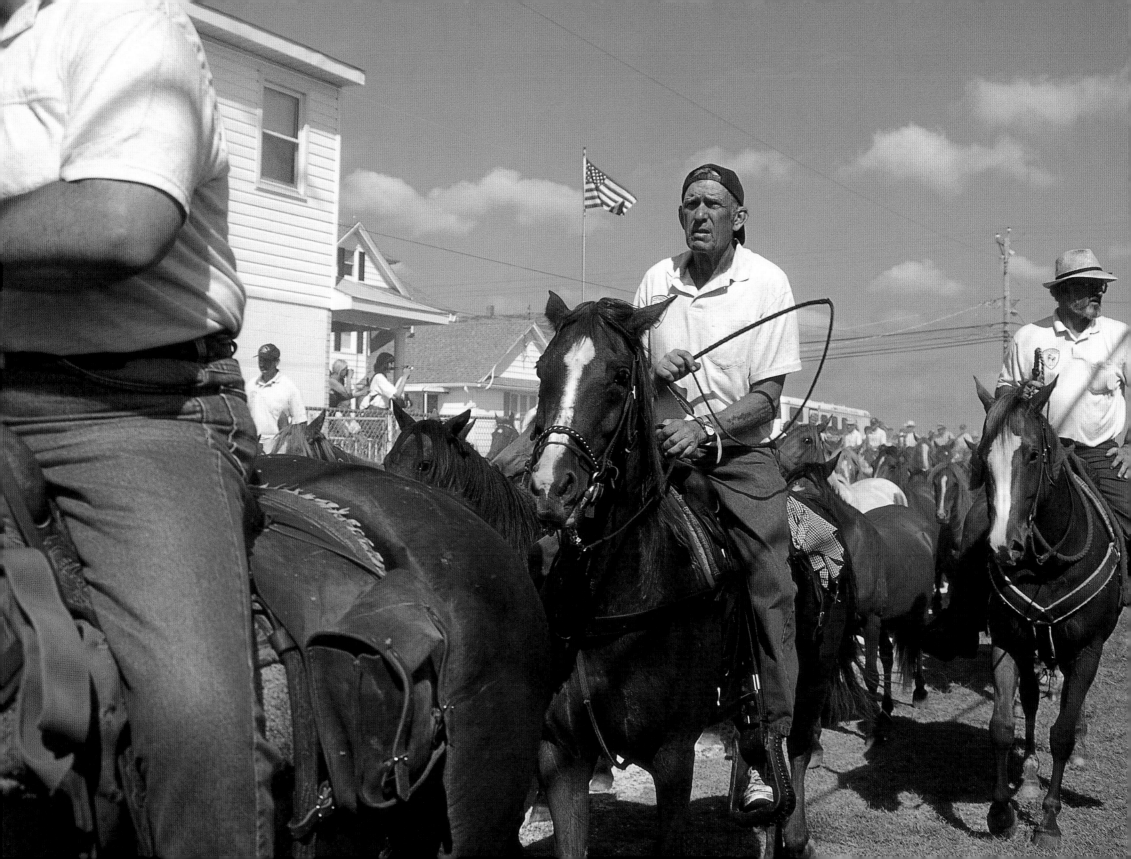

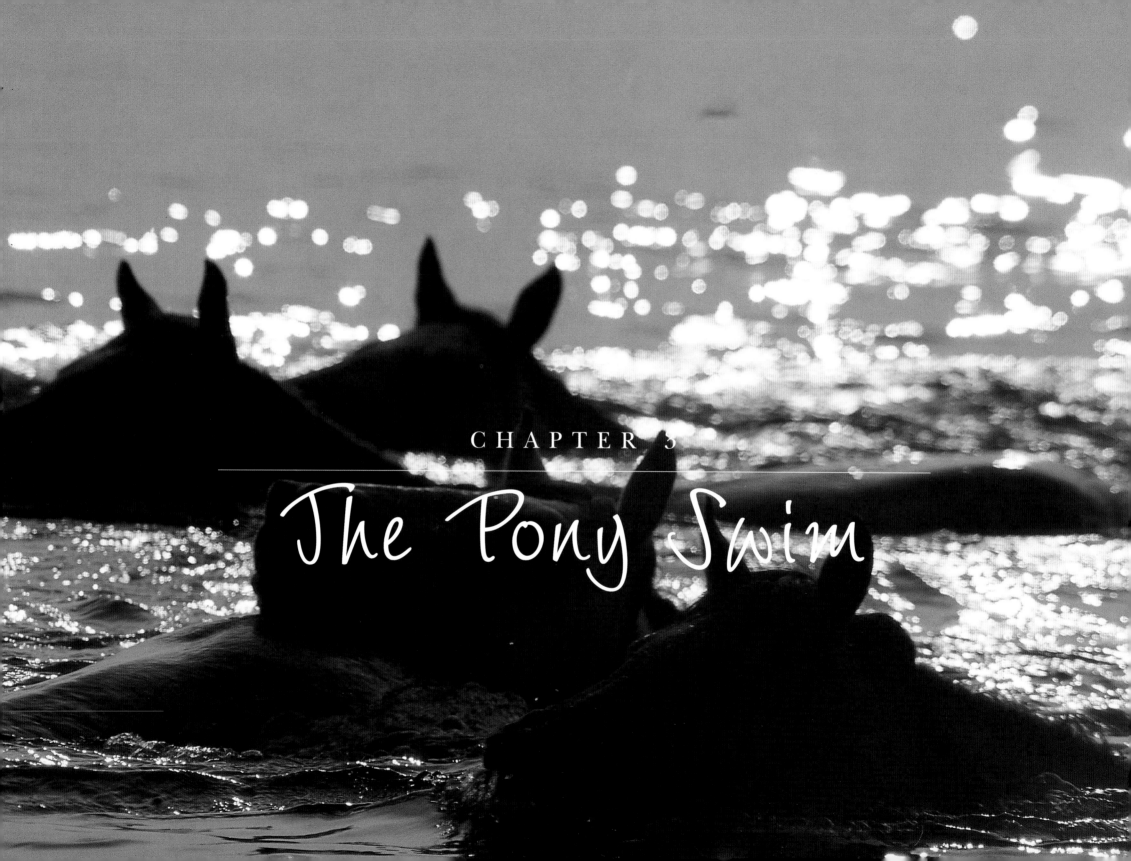

CHAPTER 3

The Pony Swim

The population of the Virginia herd is stabilized by the sale of the foals after the annual summer pony swim at an auction held by the firemen. This is a huge event, which drives the island's economy, sustains the vitality of the town, and defines its culture. The festivities commence with the firemen's carnival, which runs through the entire month of July. The fun really begins during "pony penning week" at the end of July. Tens of thousands come to Chincoteague to watch the pony swim. The actual swim takes place at the moment when the tide stops in the morning, called "slack" tide, just after low tide and before the tide starts rising. It can happen anytime from relatively early, around 7:00 A.M., until late morning, sometimes as late as 11:30 A.M.

The swim across Chincoteague Channel and the auction of the foals always take place on the fourth consecutive Wednesday and Thursday of July, after the firemen's carnival has been going on for several weeks. The swim and auction are the culminating event of the fundraising and tourist season for Chincoteaguers, leaving them with the month of August to relax and swelter. One old-timer told me they do it on Wednesday because during World War II the government requested all businesses to close on Wednesday to conserve resources. Back then, the pony penning and the auction were all done in one day. Since most of the townspeople already had the day off, it became a convenient time to do it. The cowboys would leave Chincoteague hours before sunrise, ride all the way up to Maryland (since there was no fence at the state line then), herd the animals down to the southern tip of Assateague and swim them across and parade them to the carnival grounds— all in one long, grueling day. I have also read that the current Wednesday/Thursday schedule was first established as early as 1909, but I was unable to verify either the WWII business-closing story or this report as

LEFT: Wild horses in Chincoteague Channel, swimming from Assateague Island to Chincoteague Island.
RIGHT: Waiting for the ponies.

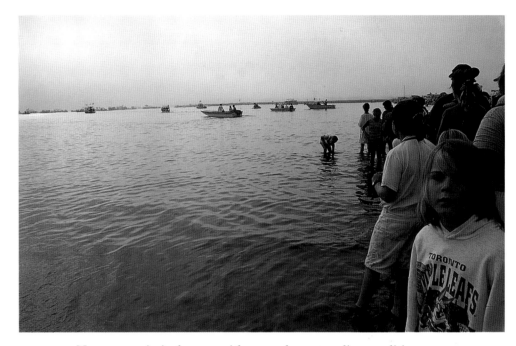

accurate. No matter. As is the way with many long-standing traditions, most people can think of no other reason except that "it's always been that way." And so it continues on this schedule, year after year. The cowboys plan their family vacations around the pony swim so they don't let their buddies down, or miss out on a great time.

Pregnant mares, small foals and the older or weaker horses are brought over to the carnival grounds by trailer to avoid any risks to them attempting the swim. The American Society for the Prevention of Cruelty to Animals monitors the swim and auction, putting to rest concerns about the treatment of the horses. Their representatives are usually very impressed with the care taken to ensure the health and safety of the animals.

The real action starts the week before the swim, when the firemen round up the animals. The cowboys round up the southern herd one day and the northern herd the next. In the summer, the first roundup is usually done Saturday, with the second on Sunday.

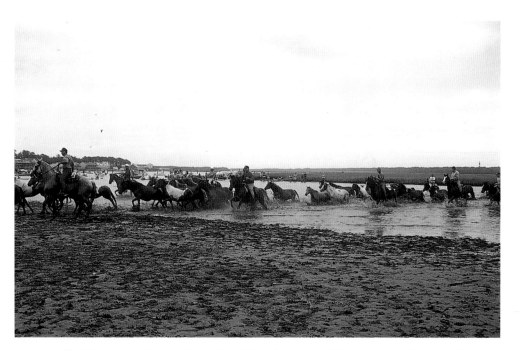

On Monday, the northern herd is taken out of the pen early, just after sunrise, and walked east a few hundred yards through a marsh and over sand dunes to the beach. There, the horses are turned to the right and walked south down the beach toward the National Seashore's Tom's Cove Visitor Center beach approximately three miles away.

At sunrise, people begin to congregate on the beach near the visitor center, waiting for the horses to appear. Hardier souls will hike north up the beach a mile or two, hoping for an early glimpse of the approaching herd. Slowly, off in the distance up the beach, some movement can be noticed. Cracking bullwhips and shouting cowboys can be heard as the herd looms into view. If the morning is cool, a mist covers the beach creating the ghostly illusion of the herd emerging from another dimension.

The Monday morning beach walk has become better known in recent years and is fast becoming a well-attended event in its own right. The crowds are becoming larger with people staking out prime viewing locations at the top of the dunes between the beach and the parking lot. Part of the allure,

aside from the breathtaking beauty of watching a band of horses moving along the beach at sunrise, is that spectators can walk along with the herd. The cowboys surround the herd as it moves, keeping the chance of escape to a minimum. People walk and jog alongside on the dunes and in the surf, looking for horses they recognize from past events, snapping photos, checking out the new foals, and just feeling the joy of watching these beautiful animals move.

Some horses, usually older foals, will bolt and dart out of the group, trying to escape with three or four cowboys giving chase. It provides great drama and always ends the same way, with a rope around the foal's neck to lead it back to its mother. This usually happens before they get to the crowds, and the errant foals are either returned to the group or brought separately to the pen.

Faster than expected, the horses are upon the spectators. They are moving at a fast walk, sometimes loping a bit, so the large group of horses migrating together moves quickly. Photographers run from one side of the herd to the other, looking for *the* shot, video cameras capture the action and children squeal with delight. The wide-eyed foals bleat and stay close to their mothers, frightened by the unnatural movement of the herd along the beach. The adults have been through this routine before, and so know the end of the trail means rest and the delivery of hay bales that taste much better than their usual fare.

The cowboys will bring the herd over the dunes into the visitor center parking lot. There is always a bit of unplanned pandemonium here as the cowboys herd the horses through the lot, trying to keep them from getting

ABOVE: The ponies are herded from Assateague Island onto a sand bar, off of which they will plunge into the Chincoteague Channel for the swim to Chincoteague.
LEFT: Walter Marks on his horse in Chincoteague Channel.
TOP RIGHT: Cowboys gather in the wildlife refuge in the early morning, ready to split up and bring in the southern herd.
BOTTOM RIGHT: Typically rainy, the spring roundup of the southern herd finishes with crossing a stream near the southern pen.

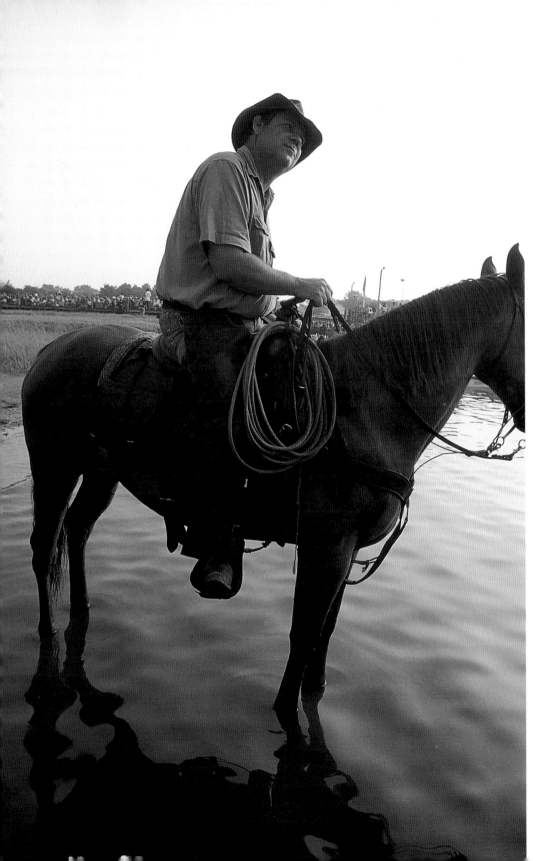
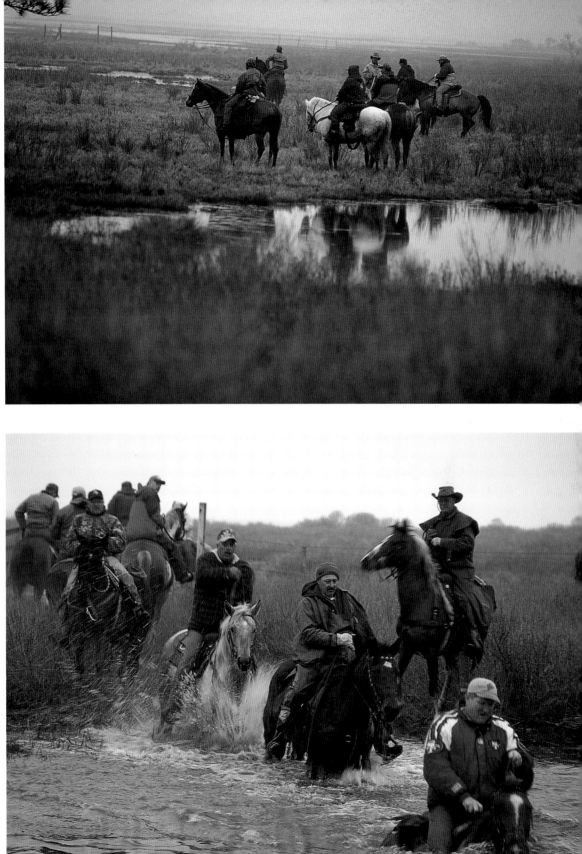

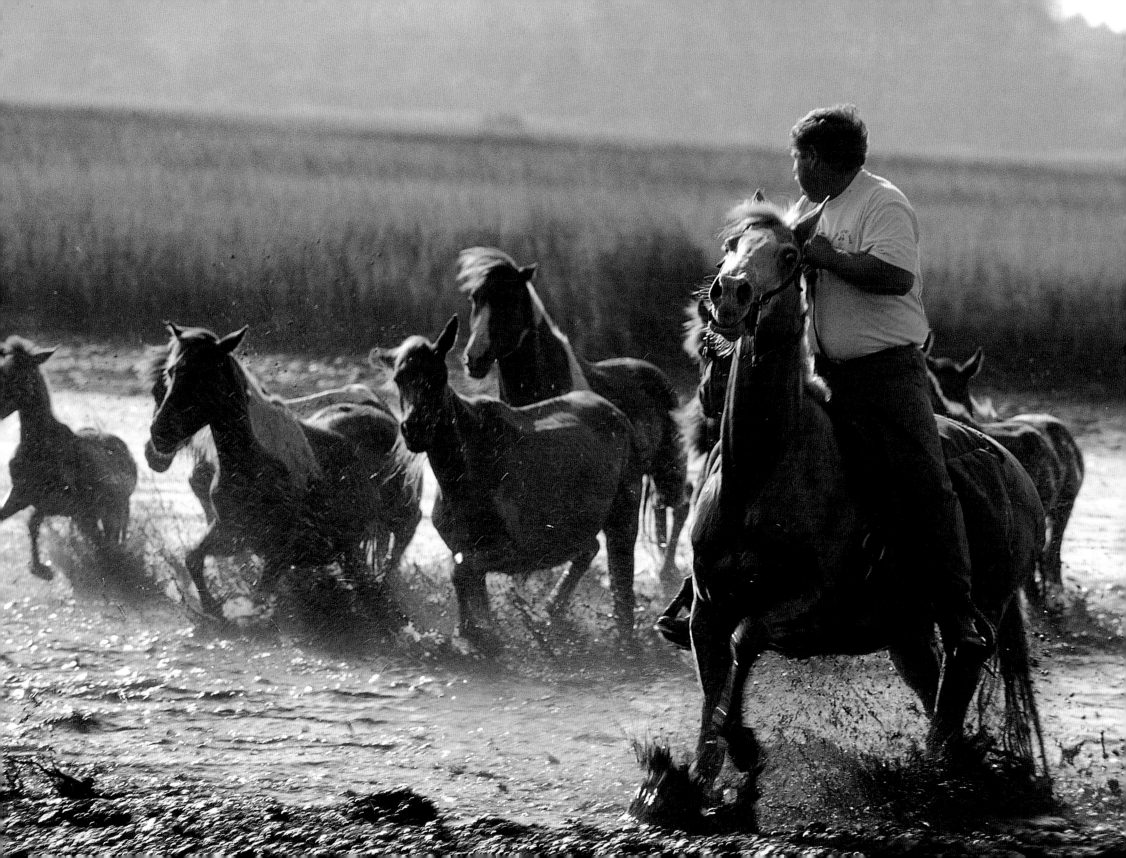

caught between parked cars, always working to keep them together so they move as one.

Once through the parking lot, the herd is brought along the road amid tourists and other visitors to the refuge and to the pen where the southern herd awaits. For the next two days, they will be gawked at and admired by thousands of visitors whose cars will clog the road into the wildlife refuge. People will surround the pen to look at the horses and see the foals that will be sold in a few days. Some will decide which of the young horses they intend to bid on. This is an exciting place for children, some of whom expect to go home with one of the famous Chincoteague ponies, making their public debut right here.

By Tuesday night, the atmosphere all over Chincoteague is vibrant. The carnival is in full swing, the ponies are rested, the children are excited, stores are open late all over the island and the merchants are ringing their cash registers at full tilt. The lines at the Island Creamery, known for its home-made ice cream, and Mr. Whippy's, the soft custard drive-through, will reach out onto Maddox Boulevard. Lines will also be long at the Island Roxy, Chincoteague's old movie theater, which shows the 1961 Disney film version of *Misty* throughout pony-penning week for free. The movie carries a sensibility straight out of the 1950s, with pseudo-folksy wisdom dispensed by crusty old timers, aw-shucks kids and slow monosyllabic dialogue. Nonetheless, it's first-come-first-serve for each show, and they are all packed. While the Marguerite Henry book certainly put Chincoteague on the map, the filming of the movie brought the island a level of fame it still enjoys. Many of the locals were employed as extras, some with speaking parts, in the film. The movie premiered in the Roxy on June 14, 1961, after which the original Misty put

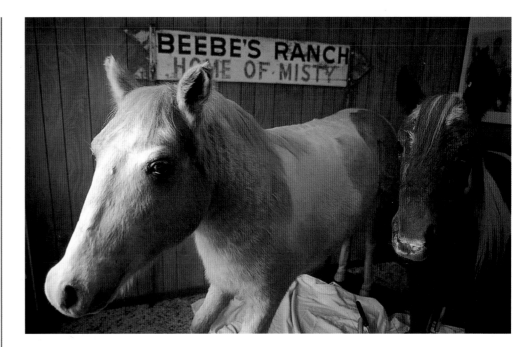

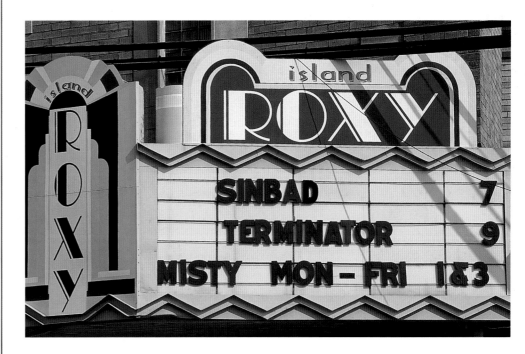

LEFT: Leaving Assateague, the ponies are run out of the salt marsh and into Chincoteague Channel for the quarter-mile swim to Chincoteague.
TOP RIGHT: One of the more bizarre yet alluring attractions on Chincoteague is Misty herself—stuffed and on display in the dining room at the Beebe Ranch where she lived.
BOTTOM RIGHT: Marguerite Henry's book, *Misty of Chincoteague*, made the island famous; Disney's movie adaptation is shown for free at the Island Roxy theatre during pony swim week.

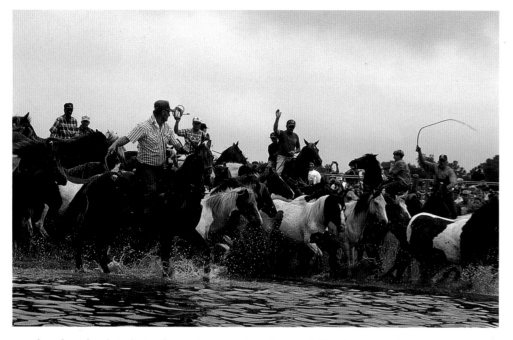

her hoof prints into the wet cement in front of the theater, where they can still be seen. Misty herself did not star in the film. Rather, a darker brown horse was used whose fur was touched up by the film's makeup artist for the part.

Many people are unaware that Misty was a real horse and the Beebe family, the main characters in the book, were real people. The longevity and depth of the "Misty" craze is extraordinary. It has almost a cult status, rivaling the slavish adoration seen from Elvis fans at Graceland. Adults will bid thousands of hard-earned dollars on the foals to fulfill lifelong fantasies of owning a piece of the "Misty" legend. A quick Internet search will find numerous websites devoted to various aspects of the Misty phenomenon, including one site just for collectors of *models* of better-known Assateague horses, with Misty and her descendants being the best known and the most coveted. At the auction, special note is always made of any horse that resembles the famous horse or any of her descendants, and these foals will fetch the highest prices. Several of Misty's descendants can even be ridden

(for a fee) at a local tourist shop on Chincoteague. The Misty of Chincoteague Foundation was established a few years ago to preserve the memory and legacy of the story of Misty, including raising funds to buy part of the farmland on Chincoteague where Misty lived, subdivided for development in recent years. A statue has been erected nearby.

And for the true acolyte, no visit to Chincoteague is complete without a pilgrimage to see the stuffed body of Misty herself (she died in 1972), next to the stuffed body of her own progeny, Stormy, at the former Beebe Ranch; admission is $5.00. Now owned by Billy Beebe, grandson of Misty's original owner, Clarence Beebe, Misty's remains are displayed in the 1940s era house on what remains of a ranch where dozens of horses once resided. For your money you get to watch a video about Misty, walk through her old barn, touch her old saddles, peer into her now cobweb-filled grain buckets, stare at the odd spectacle of the two stuffed horses standing in the former dining room of the house, look at lots of old movie paraphernalia, and of course, buy books, videos and trinkets all related to the Misty legend. Billy and his family are there to answer questions too. Billy himself had a bit part in the movie and he has the 8x10 glossy film stills to prove it. If you go during pony swim week, visit early, as the lines can get very long!

The crescendo will be reached Wednesday morning when more than 50,000 people will crowd the salt marsh between Memorial Park and Tom's Cove, a quarter-mile apart, to watch the pony swim.

Before sunrise on Wednesday, people show up to get a good vantage point in the marsh on the Chincoteague side of the channel. By 6:00 A.M., a steady stream of spectators is wading through the marsh (in which many a sandal or sneaker has been sucked off by the sticky, black marsh mud) and into Memorial Park immediately adjacent to the area where the horses come

LEFT: On Friday, the day after the auction, the adult horses are brought back to Chincoteague Channel for the "swim back" to Assateague.
RIGHT: The hard work for the day done, the saltwater cowboys watch the horses swim toward the beach on Chincoteague, where thousands of spectators wait.

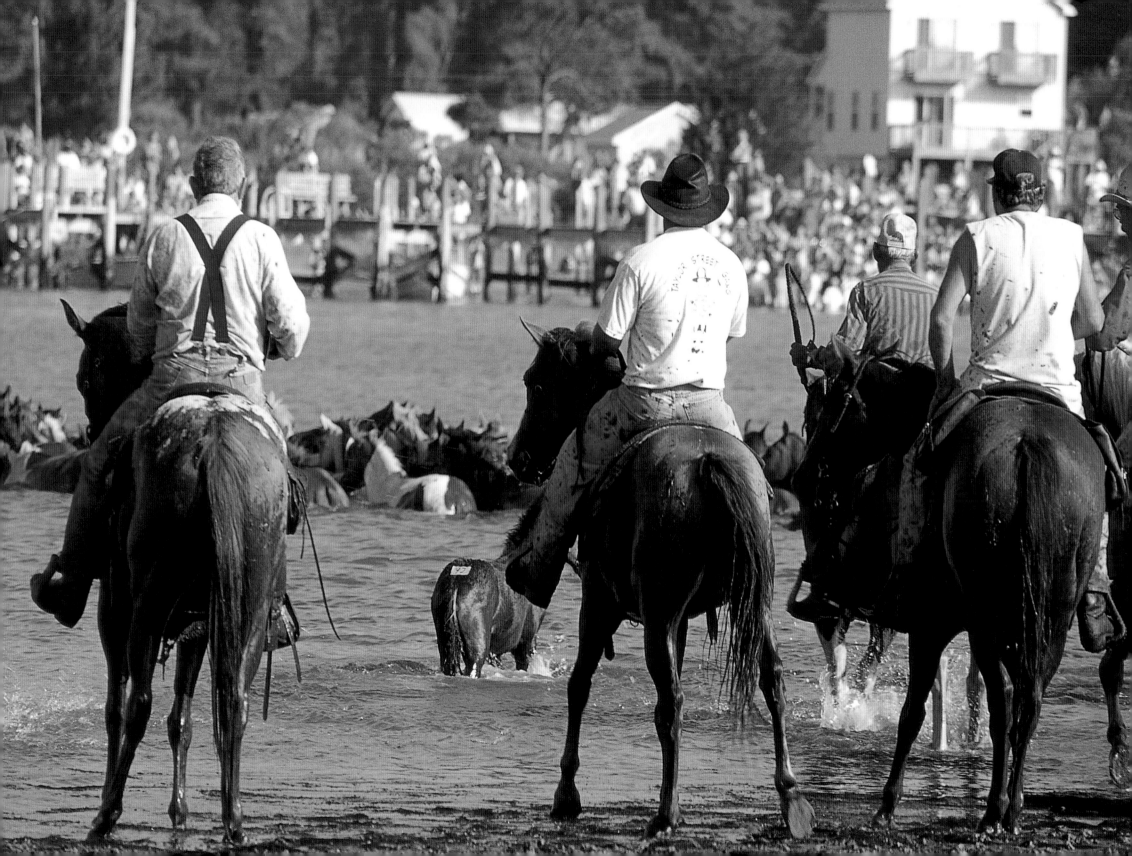

late arrivals who will inevitably share it with you. It's a genial crowd, generally polite (it *is* the South, after all), but competition can be fierce for the prime spots at the edge of the grassy beach onto which the horses emerge from the water. A party atmosphere prevails, with stories of past pony swims, pony paraphernalia and shared food and drink helping to lighten the mood during the long, wet, hot wait.

The population of the crowd is a fun mix of happy people. The overwhelming majority of visitors are from the Mid-Atlantic region, with a healthy smattering of folks from farther south (Georgia, Tennessee) and north (New Jersey, New York and New England). But occasionally you meet someone from California, or Michigan, or Japan, who has made the trip just for this event. All appear to come solidly from the ranks of the middle class. There are also always bunches of Mennonites, men with beards in black pants and clipped-together suspenders, women wearing dainty white lace bonnets and flowing blue or purple dresses. Their children dress exactly as the adults. The allure is the same for all—this is one of the few authentic and unspoiled family events left to see in America. It hasn't been bought by a large corporation, Hollywood has not homogenized it and the cowboys are not rich, spoiled stars with agents. But who knows how long this will last? Indeed in 2003, for the first time I was a little surprised to see a few Land Rovers and two Hummers (all with out-of-state license plates) cruising around amidst the sea of mid-sized sedans, pickup trucks and SUVs that usually carry the predominantly working middle-class visitors.

Eventually, a ripple will move through the crowd when a line of saltwater cowboys mounted on horseback enters the beach, moving single file through the crowd, to take their positions on the beach to receive and control the

ashore. Boats fill the channel, leaving a swath about 100 yards wide, marked by buoys, for the horses to swim through. Coast Guard and National Park officials on Jet Skis patrol the perimeter to ensure that no boats drift into the swim area. The congestion of the boats is high, with craft as small as kayaks jockeying for position with large boats (many of which are chartered for exorbitant sums to tourists) for a good place to see the horses pass in front of them. Many an anchor line thrown by an enthusiastic pony-swim-fan-cum-sailor has become tangled with those of neighboring boats.

As crowded as it gets on the water, they are the lucky ones. On the shore, thousands of spectators pour into Memorial Park, which is the easiest access. It is also the worst place from which to watch the swim, since it is behind a raised walkway that blocks the view of most of the channel where the horses will swim. The rest of the view is blocked by the boats.

Only at the edge of the marsh, standing waist deep in Chincoteague Inlet, is there an unblocked perspective of the entire swim. To get a ringside seat like this, one must arrive before dawn and stand firm against the many

ABOVE: People gather on the Assateague beach in a misty predawn to watch the horses come south.
LEFT: The pony swim is a popular family event, loved by adults and children alike.
TOP RIGHT: Tens of thousands of spectators jam the area around the pony swim.
BOTTOM RIGHT: The media love the wild horses at the pony swim. Here, the animals have just completed their swim across the Channel and are enjoying a meal of beach grass, oblivious to all the attention.

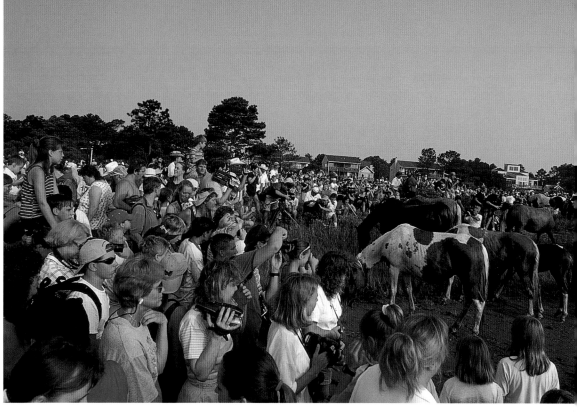
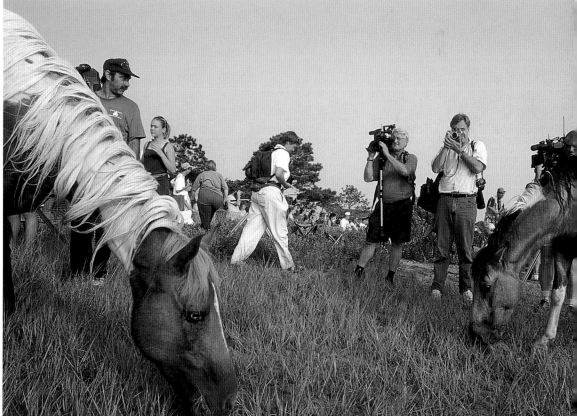

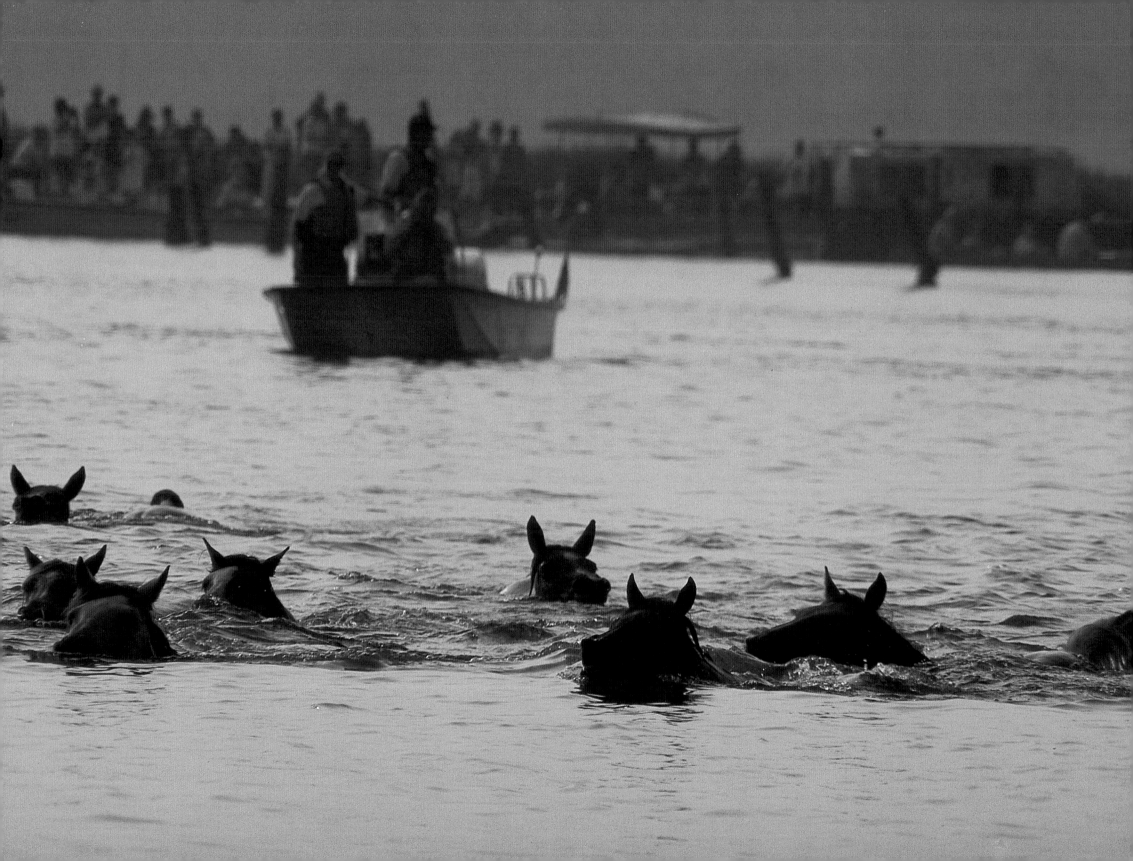

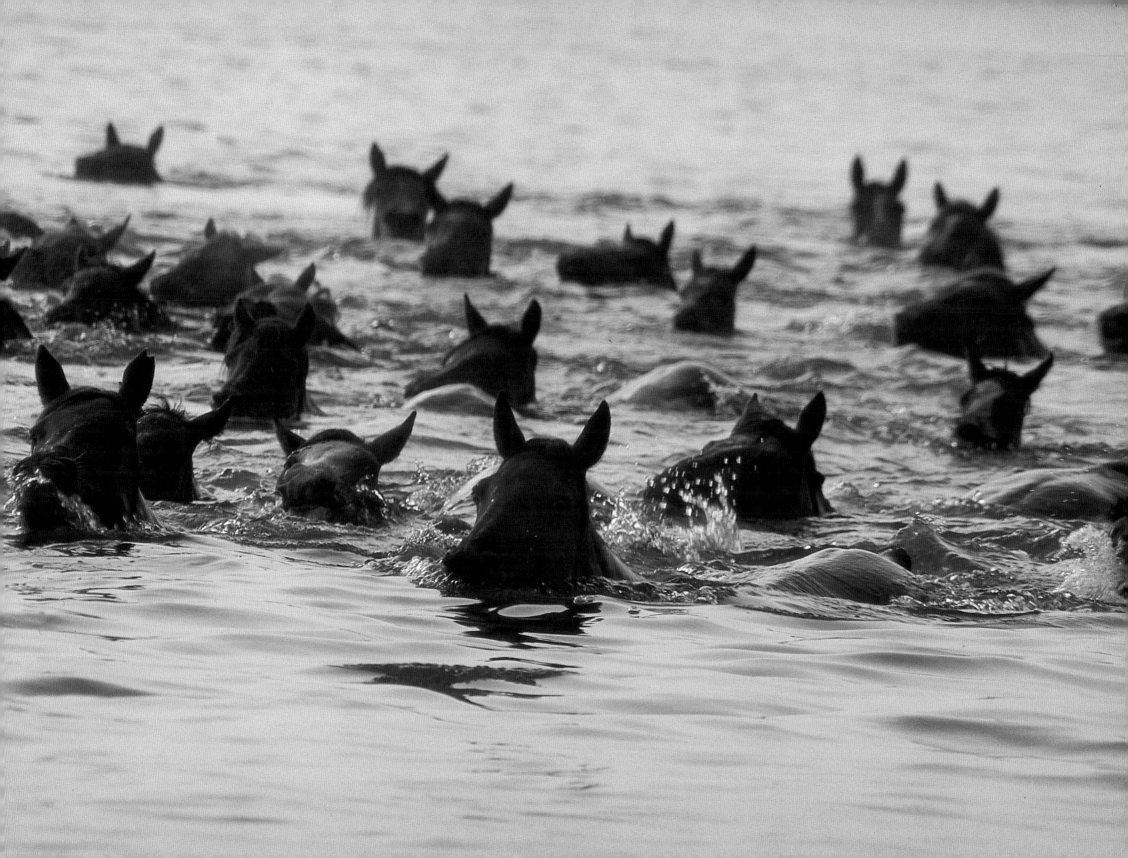

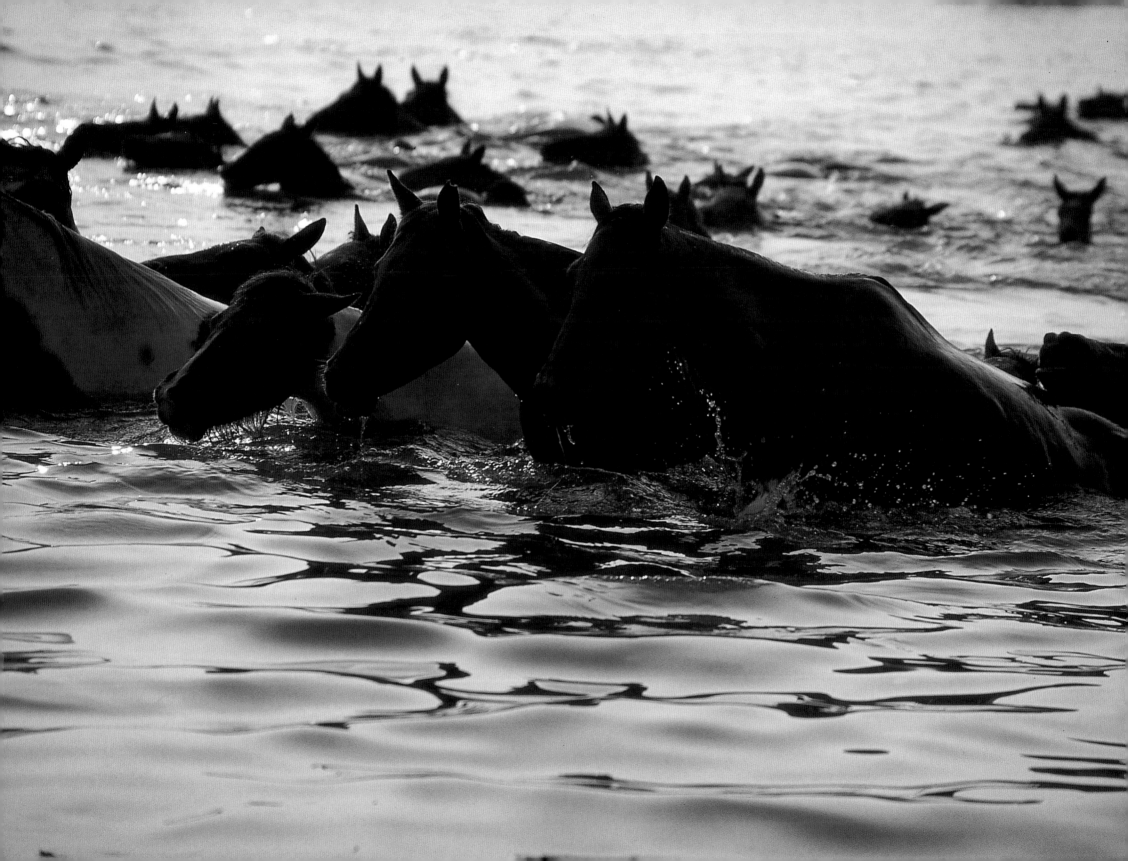

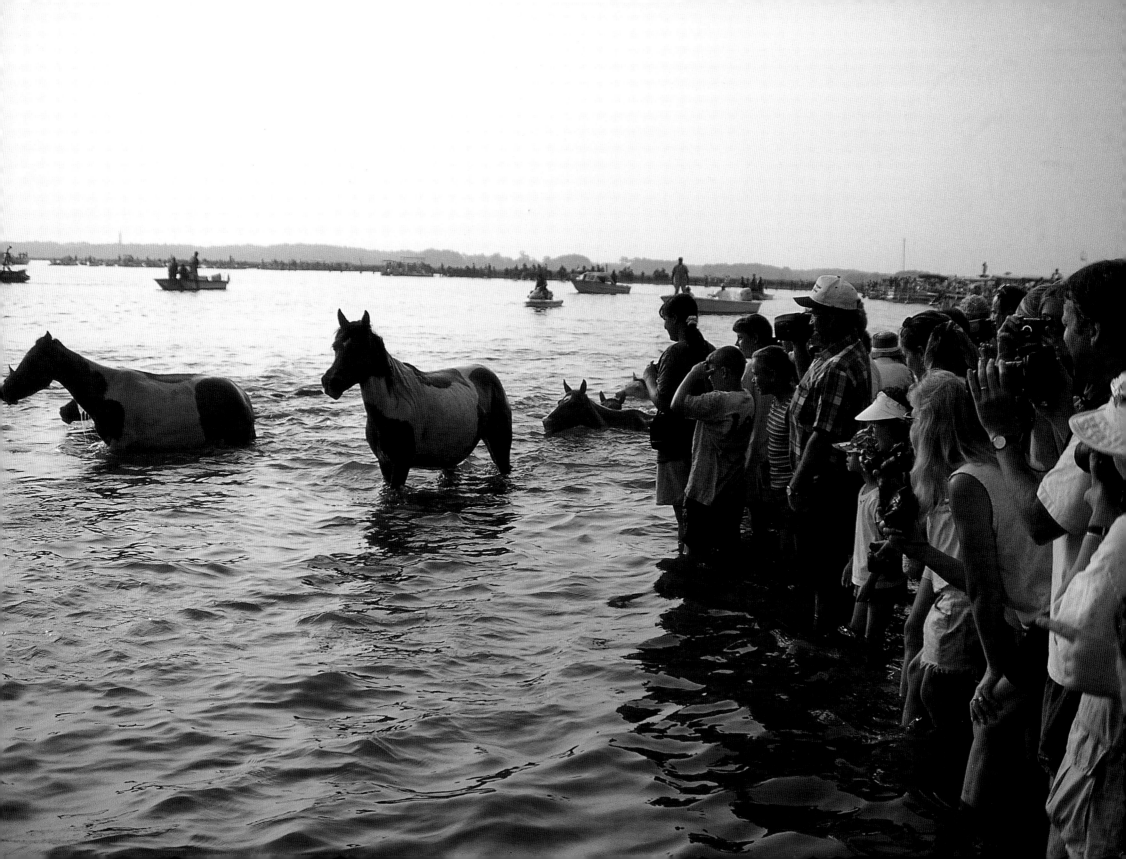

The cowboys on the beach play a game with the reporters every year, while waiting for the swim to start. They know the media love warm and fuzzy stories, so one of the middle-aged cowboys will point at two of the older men on horseback and explain to a gullible reporter that the men are his father and grandfather, respectively, and the three generations of cowboys have collectively more than one hundred years of pony pennings among them. Gathering up his gear, cameraman in tow, the reporter will rush over to the older riders, anxious to record the heartwarming story, oblivious to the leg slapping and guffaws of the cowboys behind him. The older men, who have seen this act before (and been participating in it for years), will set the reporter straight, then give an interview that is every bit as real and full of truthful lore and island charm as any the reporter could have imagined without the ploy.

As time passes and the tension rises, everyone watches the lead Coast Guard boat. The Coast Guard alone decides when the swim will happen, as the officials in charge of the water. When slack tide occurs, the Coast Guard boat in Chincoteague channel signals the moment with a smoky red flare. A cheer rises from the crowd, which then surges forward so as not to miss a single splash; the cowboys at the edge of the channel on Assateague yell and crack their whips and the wild horses plunge into the channel swimming furiously toward Chincoteague and the throngs waiting and cheering for them there.

As the horses move across the channel toward the waiting crowd, the energy level reaches peak intensity. The cheering of the crowds all around, the engines of the boats jockeying for a better view, the yelling of the cowboys, and the neighing of the swimming horses all combine as several firemen crouch down low (so as not to block anyone's view of the approaching horses) at the water's edge and anxiously wait to see which foal will be the first to come ashore. (This is important, since it will be auctioned off separately with the proceeds going to the Ladies' Auxiliary of the Fire

wild horses as they wade ashore. A little while later, a larger group of cowboys will be seen moving the herd of horses around the southern tip of Assateague, about a mile in the distance. Soon after they are seen, the sounds of the cracking of their whips and the yelping of the cowboys is heard over the flat marsh through which they have to travel to reach the crossing point. The whips are not used on the horses. They are cracked expertly to snap to keep the horses moving.

As the horses approach the spot where they will start the swim, the tension level of the crowd rises. Cameras whir and the members of the press spring to life. Only the firemen and the media are allowed onto the beach where the horses will arrive. This area is roped off to give the horses room to rest and graze once they wade ashore. Until the swim starts, the media hang out there, interviewing the firemen stationed here for crowd control, and casually filming or photographing the spectators.

PAGE 56-59: The pony swim.
ABOVE: Like conquering heroes, the saltwater cowboys enter the carnival grounds at the front of the parade herding the wild horses through the streets of Chincoteague after the pony swim.
LEFT: A cowboy watches the auction of the foals from inside the holding pen.

horses to the swim point are ferried along with their horses over to Chincoteague. Once they are all brought across the channel, the parade is ready to begin.

About an hour after the horses have swum, the firemen herd them off of the beach where they have been resting and eating and move them through the streets of Chincoteague. The throngs that filled the salt marsh and Memorial Park now line the streets and fill the fairground on the other side of town. Sometimes, a foal will dart out of the moving herd and plunge into the crowd, followed by a few cowboys on horseback. They usually retrieve it quickly, although an occasional chase through backyards does happen. The spectators love it. They cheer and point as the procession moves by with great fanfare, until they enter the fairground where the cowboys, like triumphant soldiers returning from glorious victory, lead the horses into a waiting pen where they are held for the auction, which will take place the next morning.

For the rest of the day, visitors surround the horse pen, three and four deep, straining to catch a glimpse of the famous animals. Once satisfied, the visitors are free to spend the rest of their time and money at the carnival. In years past, there were actually wild pony rides held at the fairgrounds, with a badge of honor held by the person who could remain astride a terrified wild horse the longest. The firemen also staged horse races on a race track that encircled the fairgrounds. Local boys would be the jockeys, racing their own steeds at breakneck speeds on the dirt track. The *Misty* film portrays the race in perfect Disney-esque wholesomeness. Of course, racing at the carnival and wild pony riding have been banned for years, due to the danger of injury to the riders and spectators, not to mention the horses.

Today, the carnival is more conventional. The rides are quaint; some seem to even be antiques. The main part of the fairgrounds near Main Street has all the booths where carnival-goers can buy the normal fare found at classic summertime country events: hamburgers, hot dogs, crab cakes, sodas. The local civic organizations have their stands where you can buy a raffle to

Department.) By now, the adults will have begun emerging from the water, reached the beach and shaken off the water. Others will be standing in the shallows or in the grass, mares whinnying for their foals, stallions looking about for their mares and watching out for other stallions trying to take theirs away from them, foals bleating in confusion at the spectacle amid multitudes of camera flashes popping, and media representatives trying to catch it all on film. It is an uncontrolled, yet very theatrical orchestration of events that is at once silly and thrilling, funny yet beautiful, and totally impossible to resist.

It is over in less than ten minutes.

The horses come up onto the grassy beach and immediately start eating the grass. The media swarm around them and the crowds in the water position themselves for photos with the horses as the backdrop. The horses will stay here for an hour or two, to rest after the stress of the swim and to give the crowd time to either go to the carnival fairground about a mile away on the other side of the island, or to take up positions along the road leading to the fairground. Meanwhile, the cowboys on Assateague who herded the wild

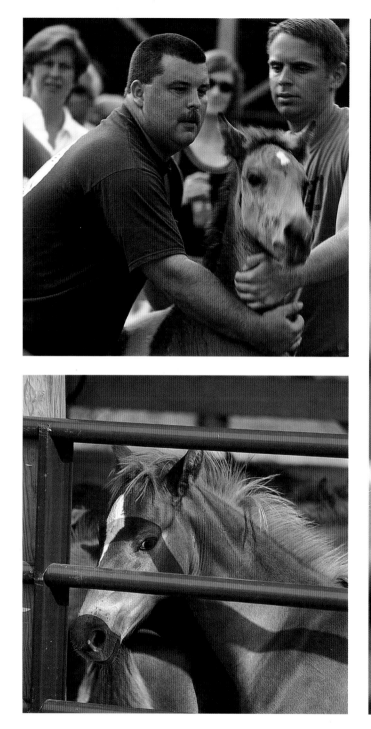

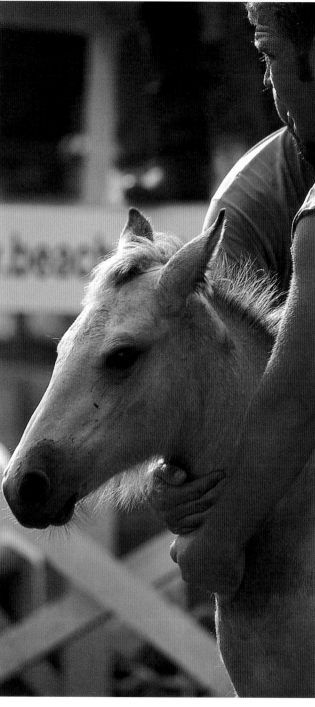

WILD HORSES OF THE DUNES

win the latest John Deere lawn tractor, or some other such treasure. A traveling Western clothing vendor sets up a tent every year where you can buy $50 cowboy boots, a straw cowboy hat, or more serious gear, from all types of tack on up to saddles and anything else you might need to keep your stable well supplied and you and your horse well appointed.

There is also a small stage on which local and regional country music acts will perform during the carnival. Just across from the stage is the always crowded bingo hall, where you can sit under yellow fluorescent lighting with one hundred other low-stakes players and buy cards for twenty-five cents. If you are not from the island, you better train your ear to understand the local twang before playing; Chincoteaguers have an accent all their own, and it only bears a slight resemblance to what you might hear elsewhere in Virginia or anywhere else on the mainland. Somehow, and I still haven't quite figured it out, a local will make the number "fourteen" sound like "thirteen" and "thirteen" sound like "tarty." It takes a little getting used to. For the more hardcore gamblers, there are booths with wheels of fortune or targets to hit, basketballs to toss and other boardwalk-style games of chance and skill.

Across Main Street from the carnival grounds one can see, through a vacant lot, Chincoteague Channel to the west, the body of water between Chincoteague Island and the mainland. On many nights as the carnival fills with people, the sunset over the channel turns the sky from orange to a shade of magenta before going purple and finally black, filling with stars.

In front of the horse pen is an open area surrounded by a fence, where the auction of the foals will take place commencing at 8:00 A.M. Thursday. Bleachers are set up behind the fence, with space in front for people to put

their own chairs, where a seat on the ground gives the best view, and allows you close access to the foals as they are shepherded around the auction field for display to the audience by strong young men, members of the fire department or sons of firefighters.

It is an unbroken rule that the first to leave a chair in a spot gets to keep that spot. The area for the chairs will be filled well before sunrise on the day of the auction. By the time the uninitiated would think to go get a seat, all of the best places have long since been occupied by chairs used as placeholders while their owners return to their hotel rooms to finish getting their night's rest. In past years, people would start lining up their chairs around the auction area late Wednesday night to reserve a good seat from which to watch the show. In 2003, the chairs began appearing by noon Tuesday, two full days before the auction.

Others with better connections perch atop official vans and trucks parked just outside the auction area. Kids climb into the trees and there is always a creative soul or two with a stepladder. The auction is not as well attended as the swim, but it is nonetheless still pretty crowded and a good seat is a very valuable asset. The auction takes a few hours, and is usually finished by noon.

It gets mighty hot at the auction, since it is held in the open sun. The men walking the foals around strain and sweat as they hold the frightened young animals to keep them from running while simultaneously giving the audience a clear view of the goods they are asked to bid on. Occasionally, one does break loose, but the wall of people stops it. In the confusion, it will hesitate, which gives a sudden swarm of burly firemen all the chance they need to recapture the creature.

Some of the foals are small and docile enough to allow even a child, usually the son or daughter of a fireman, to walk them around for the crowd to see. While the father helps, the docility of the horse is used by the auctioneer as a selling point, since, as the firemen always remind people, the horses are not tame and must be broken in (or "gentled" they like to say).

TOP LEFT: Two men control the foals as they are walked around the auction area for bidders to see. Some of the horses are spirited and give the men a workout.
BOTTOM LEFT: A wide-eyed yearling in the pen, waiting his turn at auction.
CENTER: A calm bay foal.
TOP RIGHT: A smiling young girl raises her hand for the winning bid on a young Chincoteague pony at the auction of the foals.
BOTTOM RIGHT: The auctioneer at work.

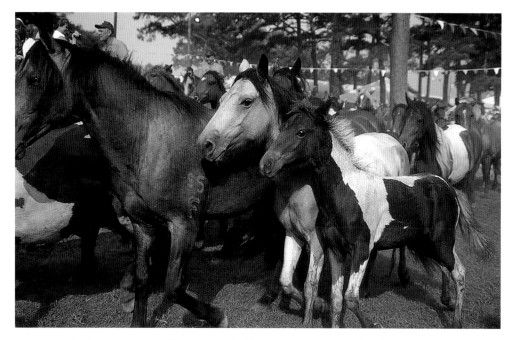

Bidders come in all sizes, including men, women, locals and visitors from afar. Many of the bidders are children, most often girls between ages nine and fifteen. There are frequently heartwarming stories to be found at the auction. Often a child will bid on a foal he or she has picked out. More than once, I have see the action suddenly stop when a bidding adult is informed that the competition is a child with limited funds, trying to fulfill a long-held dream to own a Chincoteague pony.

Occasionally the auctioneer will announce that the next foal to be auctioned off is a"turn back." He is asking for charity on behalf of the fire department. These horses have been selected by the Pony Committee of the Fire Department to be kept on Assateague. Usually these are horses that carry certain characteristics—maybe the coveted light brown pinto coloring, or perhaps the bloodline of a stallion or mare that the cowboys want to keep in the herd. The audience is asked to bid on these horses but not take them home. They stay on the island as part of the herd.

The successful turnback bidder gets to name the horse (and they *ALL* have names, some given to them by successful turnback bidders and some names given by the locals), and they get to visit the horse after the auction. They frequently return to visit during pony swim or one of the off-season roundups. Otherwise, they are not entitled to visit "their" horse out on Assateague, although some will try, to the chagrin of the Fish & Wildlife Service. They are usually politely reminded that off-trail hiking through the refuge is prohibited. Surprisingly, the prices paid for the turnback horses rival those paid for those that go home with their new owners.

At my last visit, a young teenage girl, in tears, told me how she had bought a turnback pony three years earlier and dedicated it to her aunt who had been killed shortly before in an automobile accident. She returned three years later to successfully buy a foal that was born to her turnback mare, amid great cheers and not a dry eye in the bleachers where she sat.

There is one turnback in the herd named "Hobby Horse," after one of the firemen, a man named Hobby Tull, who was killed when his tractor turned over on him while he was working. Hobby Horse was purchased by the firemen, who all pitched in for the colt, in memory of their lost comrade.

The names run the gamut from the pretty—"Water Lily," named for her habit of standing in a watering hole—to the logical—"Miracle Man," so named because he was found on the beach right after he was born, so he was hand fed by Donald Leonard, who found him, and nursed back to health—to the funny—"Nosey," who sticks her nose everywhere. There is "M & M," named not for the candy, but because she was born in 2000 and called "Millennium Milly" by her turnback buyer, but the cowboys prefer the shortened version.

In the 1920s, the foals sold for between $10 and $20. By the 1960s, the prices had risen a little, up to approximately $23.50. Today, prices for the

LEFT: The full herd enters the carnival grounds.
RIGHT: A wild horse with a yellow mane running during fall pony penning.

WILD HORSES OF THE DUNES

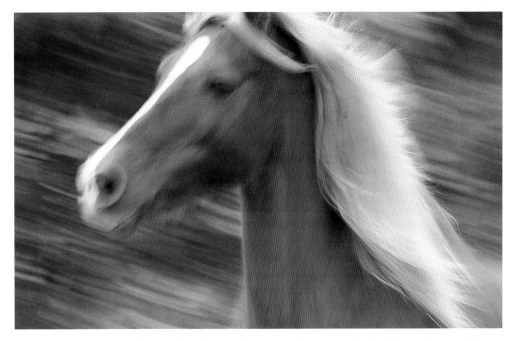

foals can go as high as five figures for one with particularly distinctive markings. The record is $10,500 for a beautiful black and white pinto bought by a woman from New Jersey in 2001. The year 2000 saw the highest total dollar amount brought in by the auction, more than $173,000. Pintos with the brown and white pattern associated with the original Misty usually fetch the highest prices. On occasion, a more mundane specimen can still be had for as low as $1,000. In recent years the average price has been around $3,000, a tidy sum for an unbroken horse that still has to be transported home! However, for people who can't control themselves and buy on impulse without the means necessary to transport their new steed home, there are vendors with trailers to hire. Virginia state law requires that only an approved trailer can be used to transport horses. Reports that successful bidders load foals into the backs of their station wagons have proven to be nothing more than sensationalist rumors, according to many witnesses who have participated in the event through the years.

Each year, anywhere from seventy-five to one hundred foals are sold at the auction. People travel from all over the country and from outside the U.S. to watch the auction and to bid on an authentic Chincoteague pony. Not only does the sale of the horses create a healthy income for the Chincoteague Volunteer Fire Department, the horses have also been established as a separate breed, and the Chincoteague Pony Association maintains a registry to track and monitor the bloodlines of the horses both on and off Assateague. There are registered Chincoteague ponies in all of the lower 48 states, and in Australia and England.

Foals younger than three months will remain on the island with their mothers until they are old and strong enough to be weaned, usually by October. Some buyers will engage the services of Chincoteague horse trainers to board their ponies, sometimes for as long as a year, and "gentle," or train them, so that by the time their pony reaches its new home, it is ready to ride.

The growth in tourism on Chincoteague has led to the construction of larger and taller buildings, including two luxury hotels. Without the funds to purchase the modern equipment needed to fight a potential fire in these buildings, the tax burden for the average Chincoteaguer would be punitive. Like most small-town fire departments it is filled with hardworking volunteers who give up an enormous amount of time to train and be available to fight the fires that inevitably take place in their community. Running a modern fire company effectively requires great personal and financial commitment. The pony auction gives this department the means to protect its community without the added strain of weak finances. Through this unique event, the wild horses have taken care of that.

CHAPTER 4

The Four Seasons

Storms have played a significant role in the shaping of Assateague, as with all barrier islands. Assateague was once connected to the peninsula just to the north of which sits Ocean City, Md. A hurricane in 1933 washed over Assateague, slicing through and carrying away the sand bridge that connected Assateague to Ocean City. The resulting inlet still exists. A look at a map however, shows Assateague distinctly west of Ocean City. This is because over the years, the ocean has steadily worked away on the beaches on the eastern side of the island, and deposited sand and silt in the western marsh side of the island, thereby moving the island westward, toward the mainland. This is common for barrier islands in the Atlantic. The result is that now Assateague is no longer in line with Ocean City, whose place in relation to the mainland has been secured and reinforced by countless breakers, piles, piers and other structures.

The red-and-white striped Assateague lighthouse is a landmark on Assateague's western side, more visible from Chincoteague's eastern side than it is from the beach at the east edge of Assateague itself. The location on this side of the island one and a half miles away from the ocean is a curious one, given the need for its beacon out at sea. Built in 1867, the lighthouse was originally 1,300 feet from the ocean, but the "movement" of the island over the years has placed the lighthouse much farther inland than its original location. More than four miles of sand has been deposited to the south of the lighthouse, forming the hook of Tom's Cove, which was not there when it was built.

In the autumn, the horses stock up for cold weather, eating more as winter approaches. They mate all year, although most seem to have their foals in the spring and early summer, meaning they are mating primarily in late summer and autumn. Then the pregnant mares need even more food to help carry them through the winter.

LEFT: Sunset over Chincoteague Channel. The shorebirds are actively hunting for dinner.
RIGHT: Assateague's distinctively striped lighthouse built in 1867.

The ponies find food all winter, but the pickings are thinner than during the warmer months. Their coats become thick. The insects die off and for a while at least, as the tourists, fishermen and beachgoers go home until the following year, the horses have the island mostly to themselves and the birdwatchers. By the end of October, the autumn bird migration is usually finished, so for the next five months life on Assateague settles into a slow, natural daily rhythm without much human interruption.

Autumn has some color, although not as much so as in the northern deciduous forests. Most of the trees on Assateague are evergreens, whose needles change color only subtly. The richest reds in late October are seen in the poison ivy that fills the pine forests. Other plants turn yellow and various shades of ochre.

By December, all is brown, and it stays that way until March, when the rains come. There may be snow on the ground in any given winter, or a passing ice storm may leave the flora encrusted like crystals in the sun, but it rarely stays long.

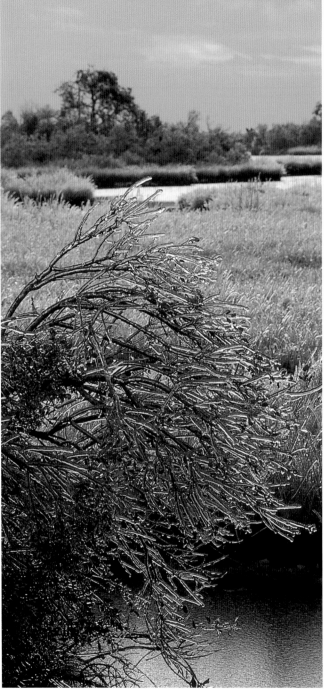

WILD HORSES OF THE DUNES

Winter on Assateague is not frigid, but many of the native plants go dormant or near dormant, thereby lowering the nutritional value they can pass along to the horses. Temperatures can remain in the 40s and lower. Staying warm can burn the calories the horses need to keep going.

While winter on Assateague is generally cold, wet and uncomfortable, the seasons there are a bit milder than on the nearby mainland. It occasionally snows, although the Gulf Stream keeps the island a little warmer than the nearby mainland, so snow rarely lasts long on the ground. I have been on Assateague during winter storms that left the roads in nearby Ocean City impassable without four-wheel drive while barely a dusting of white was visible on Assateague. More than once, I have seen snow storms cripple nearby Ocean City or Dover, Del., forty miles inland with a foot of snow, while just a few inches was on the ground on Assateague, and within a day it was gone. A big winter Nor'easter is the storm to watch for good snowfall on the island.

During cold or bad weather, the horses move inland and find shelter in the thickets of the pine forest or in the tight, stiff stands of tall salt marsh cord grass that has died off and turned brown and which has grown to as high as eight feet, thereby providing an excellent windbreak. The horses continue to move about the island, looking for food, munching on the briars, bark of trees and what grass they can find.

Assateague in the winter is a quiet and peaceful place, like something out of a dream. People still come to the island, although in very small numbers. One sees walkers on the beach but many fewer vehicles than in the warmer months. It is easy to go for miles without seeing a soul.

A Christmas Eve Nor'easter a few years ago brought an ice storm that left the island shimmering and desolate, a real wonderland. The horses crunched

ABOVE: A wild horse foraging after a December ice storm.
TOP LEFT: Pasture thistle growing in the dunes.
BOTTOM LEFT: Silhouetted beach grass.
CENTER: Icy Assateague landscape.
TOP RIGHT: Late afternoon sunlight makes the autumn salt marsh grass look like it is on fire.
BOTTOM RIGHT: Salt marsh snail.

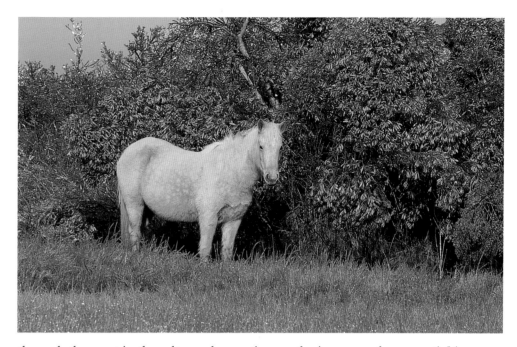

through the crust in the salt marshes, eating on the ice-covered grass, satisfying their hunger and their thirst simultaneously. The normally hot summer destination was transformed into a chilly and silent land, where the light refracted through millions of tiny frozen water crystals and the only sound was the pulsating of the waves on the beach. The horses I saw didn't miss a beat. They just kept on eating.

Chincoteague also becomes very quiet in the off season. Bird migration is most active in the spring and fall, with some birds sticking around for the summer, but in winter the birders, like the birds, mostly go south to warmer climes. Most of the tourist shops and restaurants close for the winter, with a few remaining open to serve the permanent Chincoteaguers. There is, as any local teenager will tell you, not much going on there in the colder months.

In an especially hard winter, the firemen will go out to Assateague and make sure watering holes are not iced over. They may also leave a few hay bales out for the horses to supplement their diets. A horse in distress in the Virginia herds will be cared for. The firemen will respond to reports from

tourists or pony enthusiasts of trouble with a horse, although they tell me most are false alarms. Otherwise, the animals are left alone. In Maryland, the Park Service takes a totally hands-off approach, leaving the horses to fend completely for themselves. Unlike the Virginia herds, a sick or troubled horse in Maryland is left to struggle with the capricious ways of nature.

By spring, some of the horses show distinct signs of stress, having lost significant weight over the winter months. One can see bulging ribcages on some animals, others may develop hoof problems making walking and foraging difficult. Spring is wet on Assateague, bringing rains that fill the watering holes and sustain the animal and insect life of the island. A particularly wet year can force the horses to spend much of their time standing in water. As the fauna grows back, the horses find more and better sources of nutrition. The temperatures rise and the horses begin to shed their thick winter coats.

Mares sometimes give birth to their foals during the winter. Most are born between April and early July. Since spring is usually so wet, rain is the typical forecast for the spring roundup. It is common for strong storms to pass through the area in the spring. The legendary Ash Wednesday nor'easter of 1962 sent sheets of waves over Assateague, drowning 22 horses, some of whose bodies were found washed up on the mainland. Six feet of water covered the business district on Chincoteague, one house was washed out to sea and most of the town's population was evacuated. A storm in 1992 sent a huge wave across Assateague, drowning twelve horses from the Maryland herd.

Summer is no picnic either; in fact it may be the harshest season of all on Assateague. The island environment is a very beautiful but also very tough place to live. It gets very hot—up to 100°F—and humid; this is after all, the beginning of the South, although being on the coast helps, with the attendant

TOP LEFT: Salt marsh grass makes up the bulk of the horses' diet.
BOTTOM LEFT: Summer on the beach on Assateague can be pretty close to paradise.
RIGHT: Snow geese migrating in the light of an orange dawn.

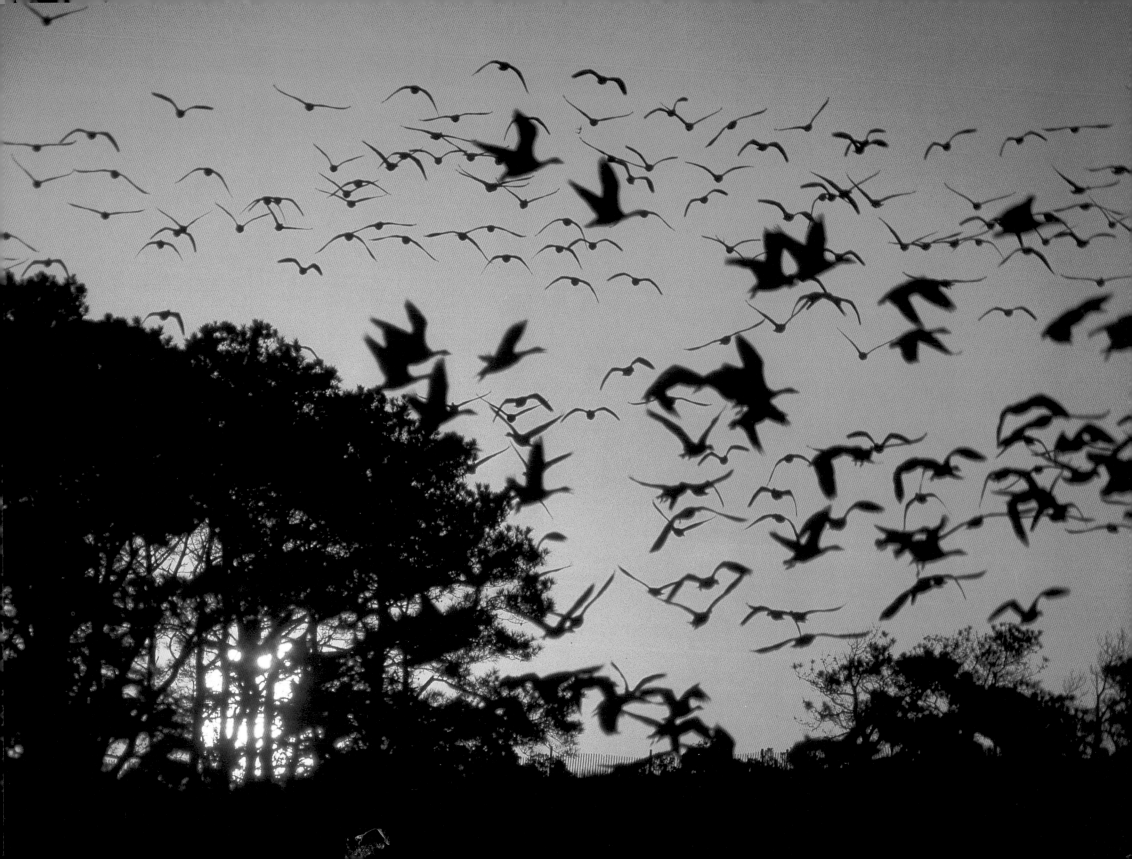

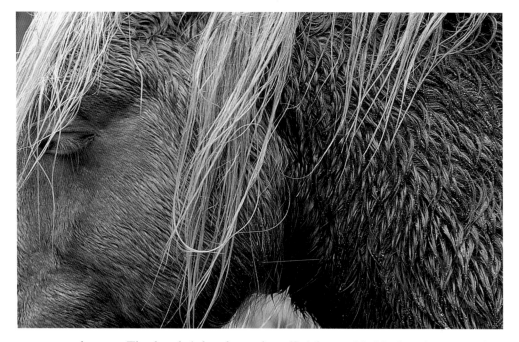

A human venturing out without protection from the mosquitoes risks serious consequences. Insect repellent is best liberally sprayed all over one's body and on the clothes, including the hat. Several times, I did not understand why the swarms would continue to just hover around me after I had applied bug repellent. I eventually learned that they were covering my hat, which I had not sprayed. They also seem to know that if they swarm around you enough, they make you run, which makes you sweat, which washes off the repellent. Also prevalent locally are three species of biting flies. One is the common black horsefly, although they come in a much larger variety on Assateague than their diminutive cousins back up north—I have seen horseflies there that were well more than an inch long. There are also two different types of biting green-headed flies, one of which is notorious for its practice of taking a piece of flesh with every bite.

Ticks are also extremely prolific, and it is a rare horse that doesn't have a few of these visibly engorged parasites attached in midsummer. A human visitor to the forests or marsh areas is well advised to check for ticks after a visit to the inland parts of the island. Fortunately, Lyme disease has not reached Assateague Island, or at least it has not been found in any ticks or mammals on the island, so one only has to worry about the prospect of being bitten by one of the disgusting little bugs but not being stricken ill by it.

The biting insects are hardly as much of a problem on the beach as they are in the marsh or grassy areas. They breed in standing water and thrive in the wet grasses. They are frequently stirred by passing warm-blooded creatures when the grass is disturbed by one walking through it. Occasionally some biting flies will bother one on the beach, but the breezes tend to keep them

ocean breeze. The locals joke about the official state bird being the mosquito. In mid to late summer, the mosquito swarms in the salt marshes and pine forests of Assateague resemble something out of a bad grade B horror movie. Some horses can be seen with countless red welts on their bellies from these parasites.

In the 1950s and '60s when major development was planned for the Maryland part of the island, authorities tried to control the mosquito breeding by digging narrow trenches throughout the salt marshes on Assateague. The thinking was that these channels would somehow carry the stagnant water from the marshes in which the bugs were breeding out into the bay. The theory was flawed and the mosquitoes continued to thrive. The marshes on Assateague are still crisscrossed by dozens of these odd, perfectly straight lines cutting through the saw cord grass. They are easy to see along the interpretive paths in the National Seashore area in Maryland, since the grass in them has never grown back.

ABOVE: After the heavy driving snow of a February nor'easter blizzard, a stallion's mane and fur is wet and knotted.
LEFT: A fallen tree is slowly reclaimed by the Wildlife Refuge.
TOP RIGHT: Autumn in the loblolly pine forest finds this mare alert.
BOTTOM RIGHT: A group of wild horses grazing, as usual, in the salt marsh on a crisp autumn day, their winter coats growing in.

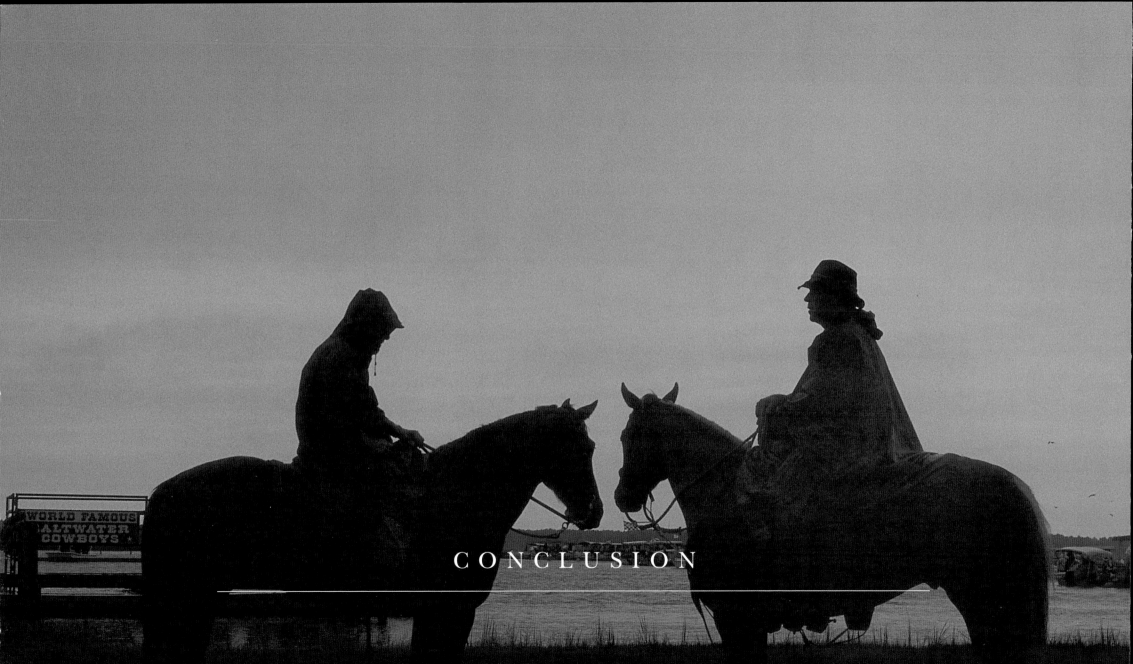

CONCLUSION

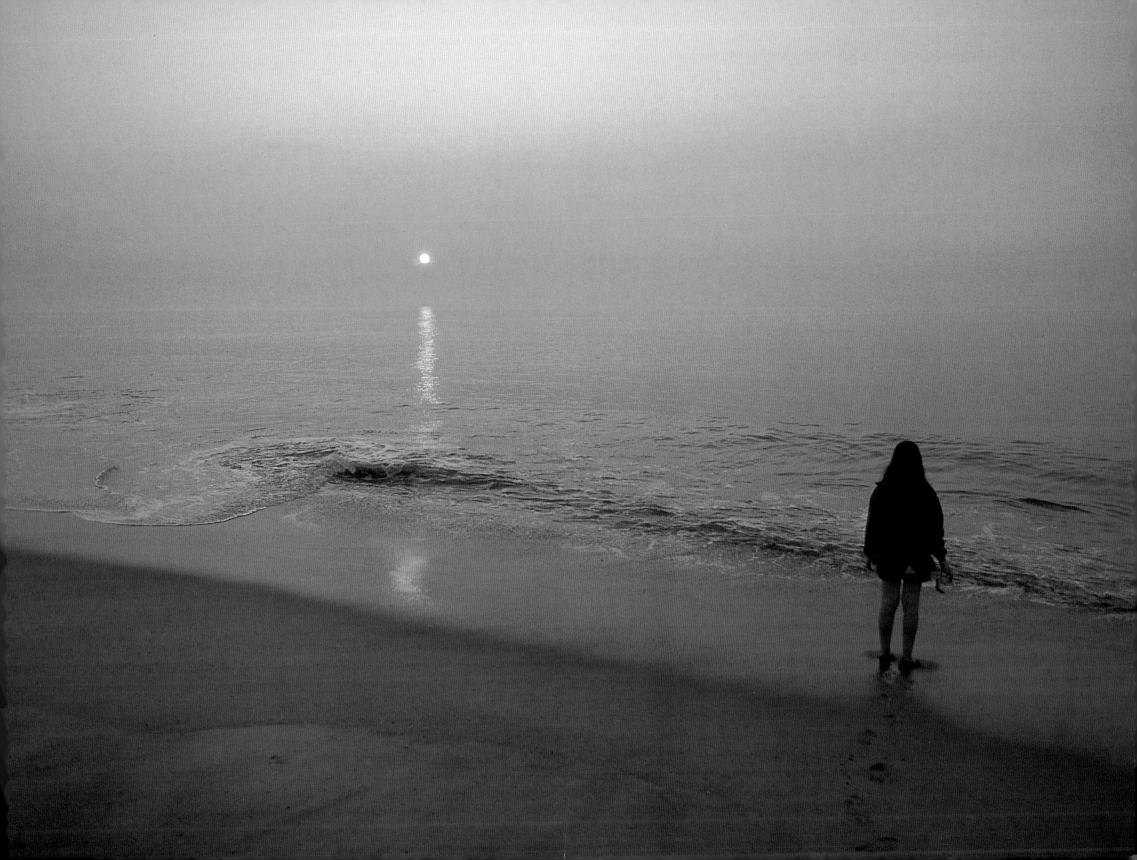

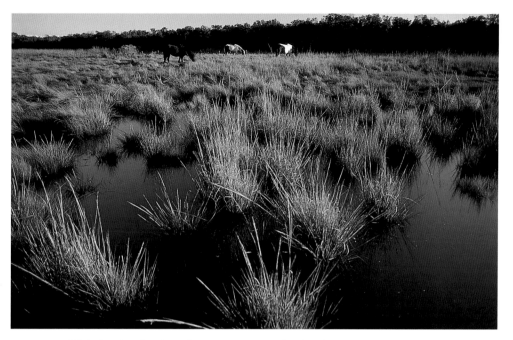

they go, but rarely stay in one place long, until late in the afternoon when the cooler evening temperatures bring some relief. They then generally move inland to find a better meal. They also move brusquely through the stiff brush, using the bushes to scratch and knock off the insects.

Horses have a twitch muscle near their rear haunches, which helps them keep the flies away, as do their constantly swishing tails. They also scratch themselves on the rough bark of the pine trees, and they can crane their necks to bite at flies on their front shoulders. But there are many places they can't reach, so an occasional roll in the sand may be used to dislodge the bugs. When that doesn't work, they suffer with their dignity intact, and move on.

Chincoteague Island suffers from the same insect problems as Assateague, but the populated island is sprayed regularly by low-flying aircraft and fogging trucks that patrol the streets. As an environmentally minded nature lover, I was at first appalled by the extent to which widespread pesticide spraying is used on Chincoteague. The pesticides settle on gardens, lawns, pets roaming about and any people who happen to be out of doors when it is applied. After spending time communing with the little winged terrorists, I have reconsidered my position. I'm still not thrilled about breathing the stuff, yet it's not likely that I or 99 percent of the other people enjoying the offerings of the island would do so without the bug-control program.

Of course, respite from the bugs is available on the beach, where it is always at least pleasant, usually wonderful, and sometimes sublime. Late in the afternoon after a hot summer day, the breeze caresses your skin like warm, soft velvet. On a rare September day, the same breeze will bring you its comfort anywhere on either of the two islands. All you need to do to feel the tender wind is to give the islands some of your time.

away. This is why the beaches are so popular in the summer with visitors. In fact, for some time, until the early 1970s there was an unofficial nude beach about seven miles north of the Virginia public beach on Assateague. It was discouraged by the park service, but officials could not keep determined people from hiking in to the relatively isolated area. They finally put up "No Nudity" signs and beefed up the patrols. They also enlisted the cowboys to help monitor the nude bathing, with unanticipated results. One fireman, Pete Savage, was captured on film by a magazine photographer giving a horseback ride to a naked young woman. When the romantic images of the couple galloping up the beach were published Mrs. Savage was not pleased. Today, there is no nude bathing.

The horses seek respite from both the flying monsters and the heat by walking along the perimeters of the island during the heat of the day; on the beach facing the Atlantic on the east and through the salt marshes out into the shallows of Chincoteague Bay on the west, seeking breezes and washing their flanks if they can with the salt water flowing through. They eat a little as

ABOVE: Wild horses in the salt marsh.
RIGHT: Waiting for the horses as the sun rises over Assateague Island.

WILD HORSES OF THE DUNES

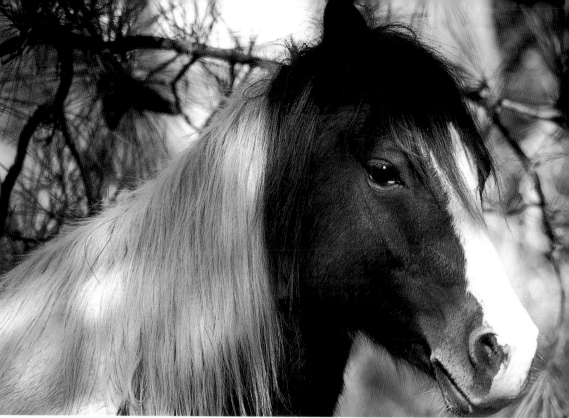
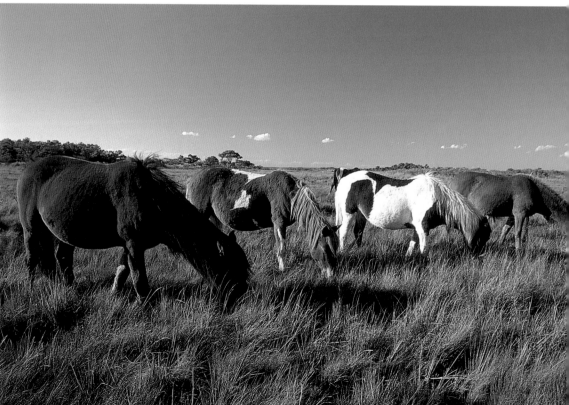

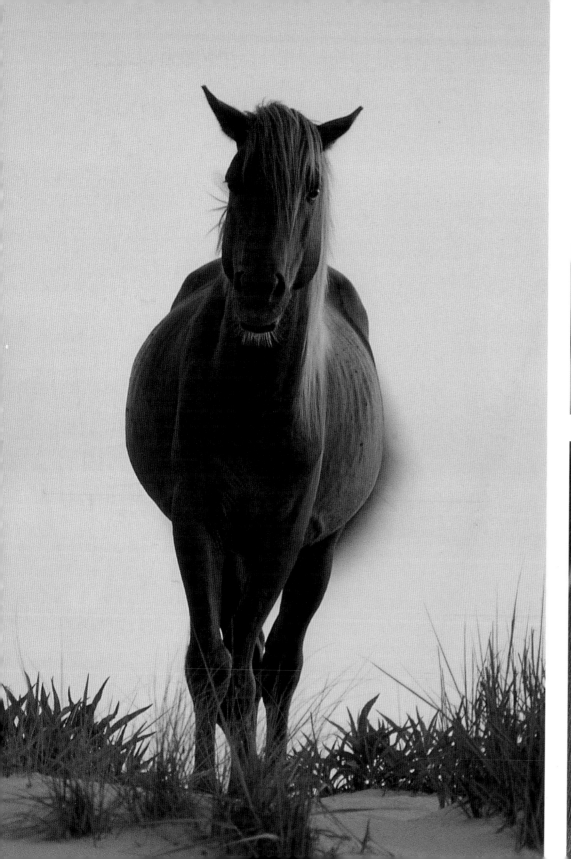
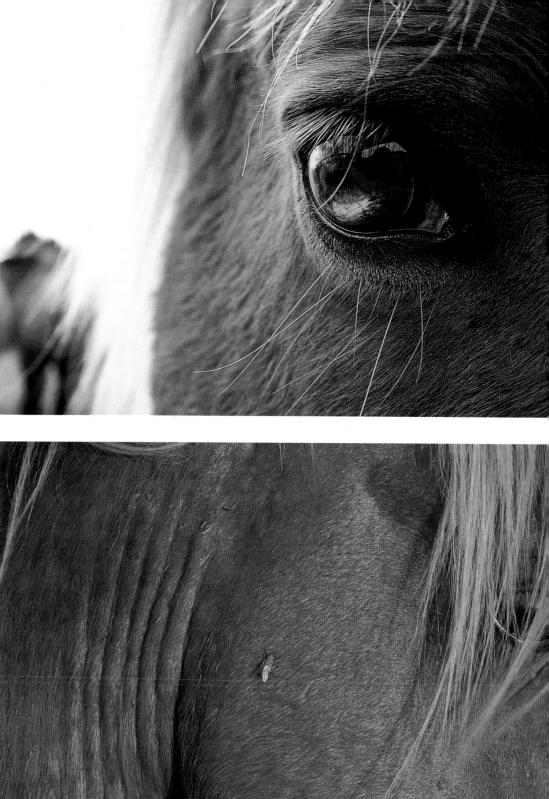

As I write, a very loud and public argument is taking place about the propriety of developing an old, unused and possibly historic Coast Guard station on Assateague, for use as an ecotourism-style bed and breakfast. Opponents steadfastly insist that Assateague remain wild and untouched, while proponents, whose primary motivation is admittedly economic, claim it adds no more intrusion to the island than is already there or has been there for many years, and will introduce the beauty of the island to even more people. Echoing a discussion taking place in communities across the country, a balance must be struck between too much exploitation and the recognition that human society is part of the ecology of every place.

This recognition is not nearly as romantic as the picture of wild horses running across a desolate Atlantic barrier island, but for me it is just as powerful and evocative. The question of whether "wildness" is alien to human culture is never debated; it is simply assumed. In our modern view of the world, people do not exist in the wild. Being engaged with the "natural" world is something we idealize. It is something very few of us actually do every day regardless of where we live.

We designate our more precious places as national parks, which allows us to believe that by doing so we have saved them from our worst practices. But this also reinforces the notion that wilderness is someplace else, that when a place or an animal is wild, then that means that it is something different and separate from what we are. We have forgotten that we humans evolved over millennia, side by side with the animals living in the same "wild" places that we now relegate to the parklands. By separating ourselves from them and from our common past, we convince ourselves that we have either stopped evolving together, or that we have evolved beyond them. Of course, neither of these is the case.

When people visit Assateague, they gain a feeling of connection with the natural world that is lacking at home. The horses reinforce that feeling. When we act in concert with nature, through outdoor activities, on sea, in the mountains or the woods, even just going to a nice, uncrowded beach, something inside is stimulated, unlocked and set free. It feels as though we belong in that place, both physically and emotionally. Assateague did this to me with so much power that I was driven to return again and again to capture the images found in these pages. Assateague and its horses have been not just a powerful muse for my art, but also a teacher of the appropriate place of people in the natural environment.

The wild horses roaming Assateague Island are not acting out any evolutionary imperative set in place by nature. "Nature" did not put the horses on Assateague, yet we recognize them as wild creatures. Some people make the argument that the horses aren't native to the island and so should have been removed. But there is probably no place on earth that has not been touched by man's hand, so where do we draw the line?

The wild horses of Assateague Island need human society to sustain them and also to keep them from overrunning the island, and turning it into one large stable. The people of the region need the horses to help them sustain the 21st-century economy that they have built. We are all in this together. We always have been.

LEFT: Two cowboys discuss the morning's work, ready to start as a rainy day dawns on the pony penning.
PAGE 78 LEFT: Just after a June sunrise on the dunes, a blond stallion surveys the beach.
PAGE 78 TOP RIGHT: The soulful eye of a penned old timer.
PAGE 78 BOTTOM RIGHT: A green-headed fly on a horse's cheek.
LAST PAGE: Assateague sunrise.

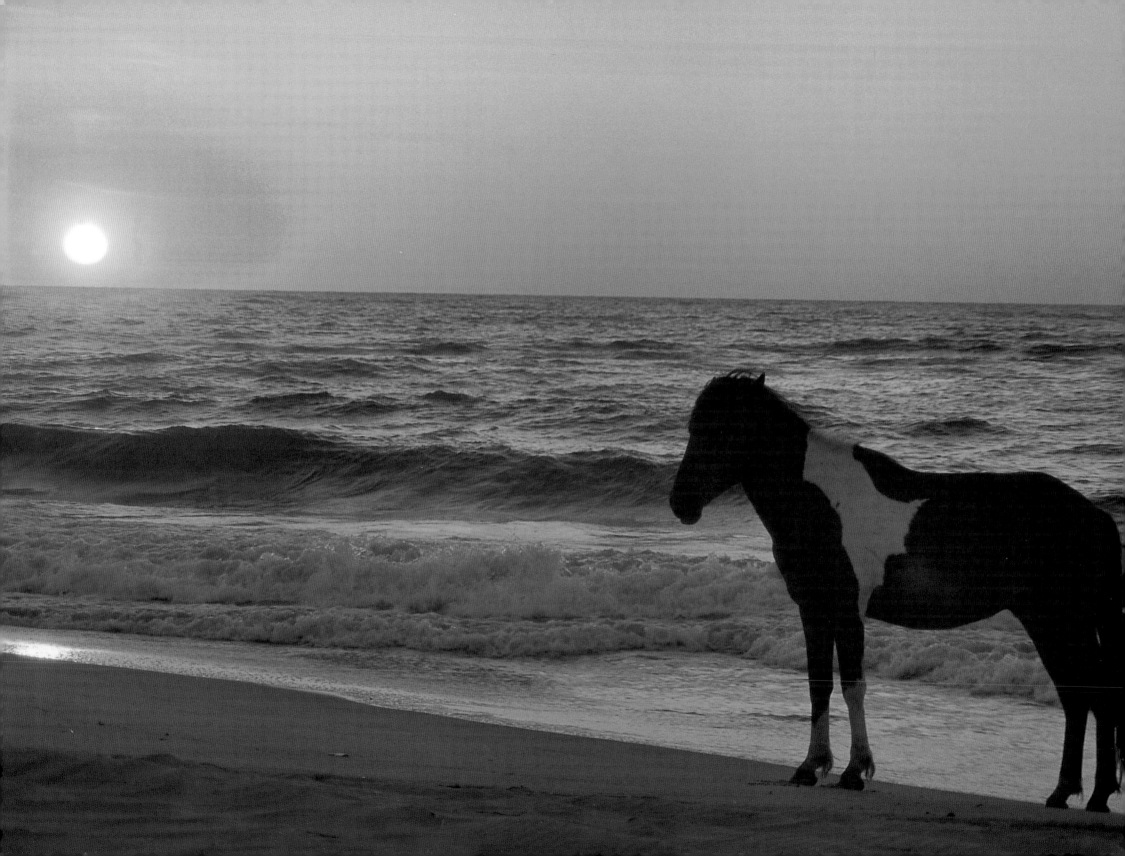

BIBLIOGRAPHY

Holden, Peter. "The Pony Swim, Chincoteague's Annual Roundup." *The World and I* (August 1997): 181-188.

Keiper, Ronald R. *The Assateague Ponies.* Centreville, MD: Tidewater Publishers, 1985.

Mariner, Kirk. *Once Upon an Island: The History of Chincoteague.* New Church, VA: Miona Publications, 1996.

Mears, Robert H. *The Watermen and Wild Ponies: A Chincoteague Waterman Remembers Life on Chincoteague and Assateague.* N.p., 1994.

Pleasants, Bernie. *Chincoteague Pony Tales.* Columbus, GA: Brentwood Christian Press, 1999.

Showard, Charles N., and Moore, Kevin N. *Teager: Life on Chincoteague and Assateague Islands.* Lewes, DE: Marketplace Merchandising, 2003.

Urquhart, Bonnie S. *Hoofprints in the Sand: Wild Horses of the Atlantic Coast.* Lexington, KY: Eclipse Press, 2002.